THEN & NOW®

SANTA ROSA

OPPOSITE: This image was taken on April 1, 1916, at Santa Rosa's first-ever Safety First Day. Perhaps it was also the last Safety First Day, but the photograph shows Fourth Street near the intersection with Pierce Street on the far left. It also provides a glimpse of the city's important figures of the day, including Luther Burbank and Sen. Herbert Slater, seated at the rear of the car. The home of Frank Doyle, president of the Exchange Bank, can be seen at the back left. (Courtesy Sonoma County Museum.)

SANTA ROSA

Eric Stanley

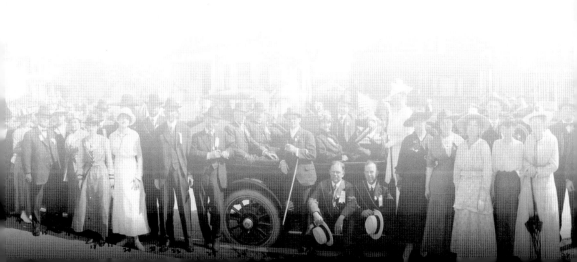

To Dede, Marron, and Ian, for their love and patience
despite several evenings of neglect

Library of Congress control number: 2008931758

Published by Arcadia Publishing
Charleston, South Carolina

Printed in the United States of America

Then and Now is a registered trademark and is used under license from
Salamander Books Limited

For all general information contact Arcadia Publishing at:
Telephone 843-853-2070
Fax 843-853-0044
E-mail sales@arcadiapublishing.com
For customer service and orders:
Toll-Free 1-888-313-2665

Visit us on the Internet at www.arcadiapublishing.com

ON THE FRONT COVER: A policeman can be seen directing traffic at the corner of Mendocino Avenue and Fourth Street in this 1940s view from the courthouse looking north. Overarching the road is the Redwood Highway sign, marking the route that opened to some fanfare in 1924, drawing travelers north. A significant change for Santa Rosa occurred in 1949 when the Highway 101 bypass rerouted the old highway that coursed through the city center. On the right is the Rosenberg Building, virtually unchanged in the two images. The Rosenberg Building was built by Fred Rosenberg and his father, Max, a Santa Rosa businessman and store owner who opened his first Santa Rosa retail venture in 1896. On the left is the Exchange Bank, which occupied this site for over a century. (Courtesy Sonoma County Museum.)

ON THE BACK COVER: This elevated perspective of Fourth Street, looking east, was taken in 1945 during a World War II war bond rally and parade. The image provides an unobstructed view down Santa Rosa's main east-to-west artery and central downtown area. (Courtesy Sonoma County Museum.)

Contents

ACKNOWLEDGMENTS

It is amazing how supportive people are of a project like this. Even complete strangers seem attracted to the idea of seeing how the past overlays with the contemporary world around us. So first to the random guy on Sebastopol Avenue who inquired about the book, the desk clerk at the Hyatt who let me shoot from the upper floors, and the folks at the Cantina who let me hang over their balcony, thanks; those interactions made me feel like I was doing something special.

More seriously is my gratitude to Gaye and John LeBaron, who let me draw on their substantial collection of images as well as their truly amazing store of knowledge. I would have been nowhere without their considerable help. Besides, it was an absolute pleasure to sit and watch them debate over which corner some building actually sat on. It was sort of an "old, older" duel of supreme masters. (They will know I am not referring to their age!)

Thanks to Tony Hoskins and Katherine Rinehart at the Sonoma County Library. They are always so willing to help and so good at what they do. The library's collection is heavily represented in this work. I also need to thank Lee Torliatt, who has done a few Arcadia books himself, for sharing some of his wisdom and giving me some tips on the Don Meacham photographs at the library. Beyond that, Lee is also just good for a laugh.

I also extend my sincere thanks to everyone at the Sonoma County Museum for being supportive of my project. I enjoyed plumbing the fine collection there for great images. The collection, as a whole, deserves to be held in greater esteem throughout the community. Thanks too to Sarah-Jane Andrew for listening patiently to any boring tales I told during lunch about working on the project.

Finally, to my dentist, Dr. Robert Gilbaugh, whose office is near the photograph of Sonoma Avenue in chapter two. He had nothing to do with this book, but I have not been in for an appointment in a while, and maybe this will help make up for it.

INTRODUCTION

Santa Rosa, California, is still a small town. Quiz its residents and many will say so. Yet in recent years, Santa Rosa's population has exceeded 157,000 individuals, making it the fifth largest city in the San Francisco Bay Area.

While often steady, growth was relatively slow for Santa Rosa. The city, founded in 1854 on part of an 1841 Mexican land grant, was principally settled by farmers coming from the southern part of the United States. Agriculture became the predominant source of wealth. By the beginning of the 20th century, Santa Rosa, still only a city of about 6,000 residents, was the hub of an agricultural empire, boasting three railroad lines that hauled the diverse wealth of the fields and orchards to near and distant markets. The money generated by agriculture, particularly by hops, helped the city become established in the last quarter of the 19th century. The town was promising enough to attract men like Mark L. McDonald, a well-connected entrepreneur who bought up Santa Rosa's water company, developed homes on McDonald's Addition, and was instrumental in promoting the second railroad line. The handsome, small town suffered a terrible setback with the 1906 earthquake. Santa Rosa rebounded, its leaders showing great determination in building a new city, with a few elements of "old" Santa Rosa still in the mix.

An anticipated influx of people and businesses with the opening of the Redwood Highway in the 1920s and the construction of the Golden Gate Bridge in 1937 did not really materialize. But after World War II, the rise in population did accelerate. Postwar developers pushed the boundaries of the city outward, creating neighborhoods where once there were only orchards of prunes, walnuts, or cherries, Montgomery Village being one prominent example. Santa Rosa began to look a little more like a city and less like a farm town, but only to a degree.

The Highway 101 bypass opened in 1949, bisecting the city, creating challenges, and shifting the course of the town's development. Another quake in 1969 inspired a flurry of urban redevelopment and some dramatic changes in the makeup and feel of the city. The incredibly diverse agriculture of past years began to slip away as vineyards and wineries became more numerous, and apple orchards and other agricultural pursuits faded away. Yet, at the same time, new industries began to make their mark on the city. Technology companies such as Hewlett Packard arrived. Santa Rosa's growing identity as wine country further shifted the city away from its dusty agricultural and shipping roots, adding more refined layers that catered to tourists as well as food and wine connoisseurs.

Today, in many ways, the city is at a crucial juncture in its history—attempting to retain some of the small-town, agricultural charm of past years, while continuing to grow. It is a tricky balance, to say the least. The push and pull of past and future makes Santa Rosa a complex layering of then and now. One sees in the newspapers and hears in discussions the angst of these countervailing forces—from the debate over reuniting Courthouse Square and over the heavy development on Fountaingrove ridge, to the oft-repeated lament for the torn down courthouse, and concern over the fact that the freeway and

the downtown shopping mall essentially bisect the heart of Santa Rosa. Civic leaders and citizens seek ways to put back what was lost and seek out solutions that can preserve or even re-create what was best about Santa Rosa's past.

Compiling a Then & Now book is a fascinating exercise. First off, even starting from the premise of then and now can be difficult. The whole idea implies that there is quite simply a then and a now to deal with. Of course, nothing is ever that simple. One quickly realizes that there are many, many thens. But that is what gives this study of Santa Rosa its compelling elements—the way that multiple layers of the past intersect with the city of today. Writ on the urban landscape is the record of events such as earthquakes, the arrival of the railroads, the opportunities of the postwar years, the development of the wine industry, and the attempts to retain or put back elements of the past for the benefit of today. The multilayered then and now narrative of Santa Rosa is one well worth reading.

AROUND THE SQUARE
THE HEART OF SANTA ROSA

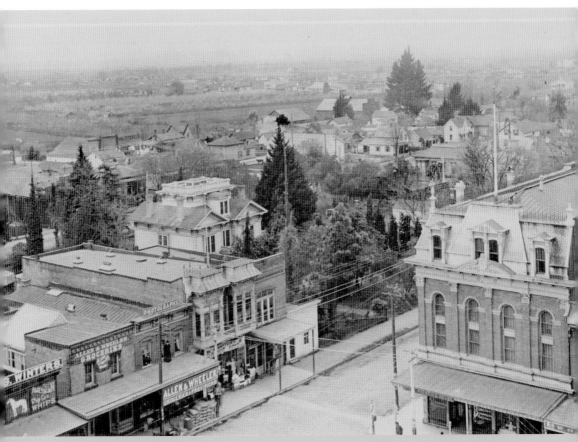

In 1853, Julio Carrillo, son of a Mexican land grantee, donated property for a central square. In 1884, the city erected a courthouse right in the middle of Julio's plaza, which provided the elevated vantage point for this image taken in about 1890 toward the southwest. At the time, the city had only about 6,000 people. This was the part of Santa Rosa that always aspired to cityhood, even when the limbs of fruit trees very nearly brushed up against its finest buildings. (Courtesy Sonoma County Museum.)

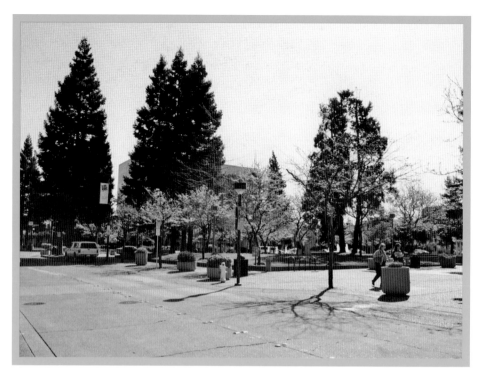

The late-19th-century image below of Fourth Street and the courthouse shows Exchange Avenue to the right and Hinton Avenue across the square on the east side of the courthouse. The modern image shows that Hinton and Exchange Avenues were eliminated following the demolition of the 1910 courthouse in 1970. Fourth Street, just east of B Street *c.* 1900, shows a drugstore, George King's grocery store, and a barbershop. Today that section of the block is dominated by restaurants. (Courtesy Sonoma County Museum.)

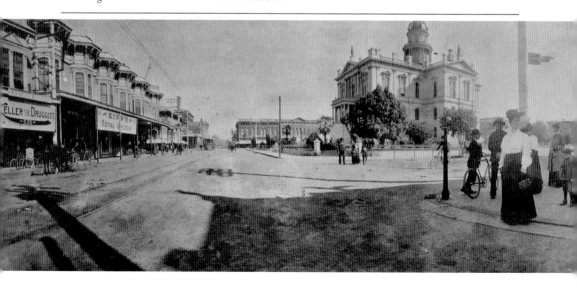

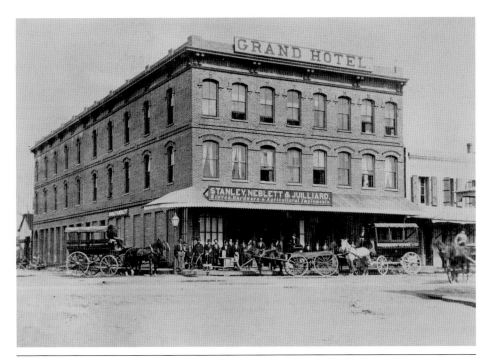

The Grand Hotel, built in 1873, was located in the heart of downtown at Main and Third Streets. It was destroyed in the 1906 earthquake. One of the few people on the street in the early morning hours when the quake struck saw the Grand collapse following a sound like wagon wheels on cobblestone and a visible wave passing through the street. Several hotels operated in the heart of Santa Rosa at the end of the 19th century, catering to traveling merchants and others. The modern image shows a bank occupying the former site of the Grand Hotel. (Courtesy Sonoma County Museum.)

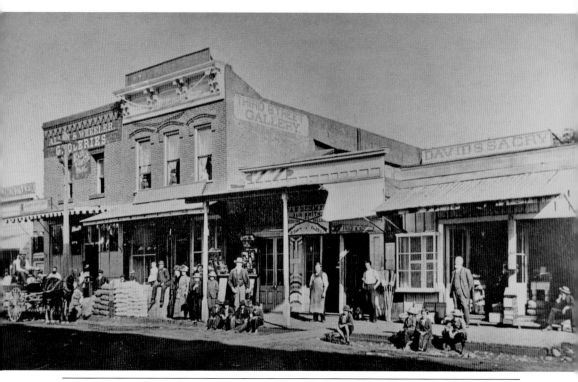

An early shot of Santa Rosa, *c.* 1885, shows several businesses along Third Street at the south end of Exchange Avenue near the courthouse. A bank with a modern sculpture now occupies the site that once advertised Allen and Wheeler Groceries, the Third Street Gallery, and a store owned by David S. Sacry. Sacry came to California in 1852 and apparently committed suicide by jumping off a steamer into San Francisco Bay in 1904. (Courtesy Sonoma County Museum.)

AROUND THE SQUARE: THE HEART OF SANTA ROSA

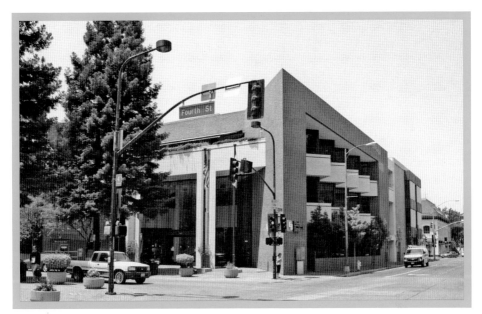

When a new county courthouse was built in Santa Rosa in 1884, the old courthouse property was auctioned off. By 1890, it became the home for Manville Doyle's Exchange Bank. The Exchange Bank has remained at that location, Fourth Street and Mendocino Avenue, ever since. A modern brick building now houses the bank at the prime Santa Rosa intersection, and the Exchange Bank remains an important pillar of the Santa Rosa community. (Courtesy Sonoma County Museum.)

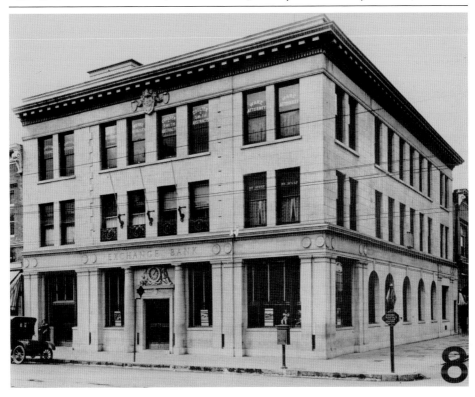

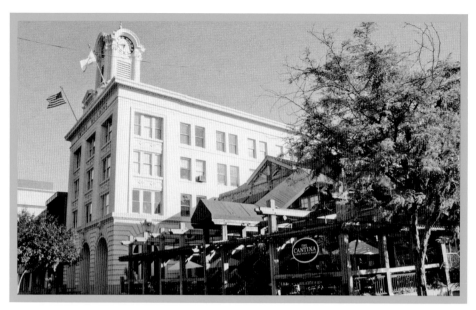

The historic image below shows the Fourth Street end of Exchange Avenue, a corner prominently occupied by the Bank of Italy and the Savings Bank of Santa Rosa, later known as the Empire Building.

The Empire Building remains a highly recognizable historic structure in Santa Rosa, while the site of the other building is now occupied by the Cantina Restaurant. (Courtesy Sonoma County Museum.)

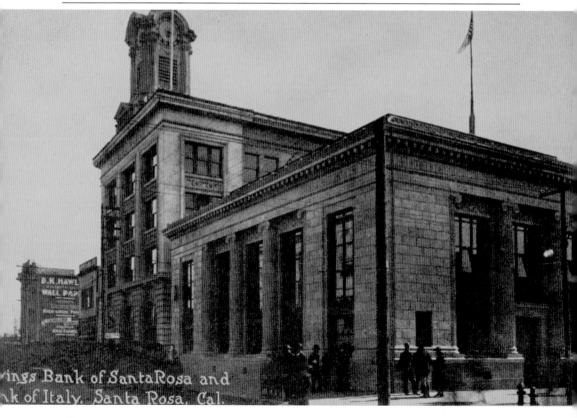

ings Bank of SantaRosa and
k of Italy, Santa Rosa, Cal.

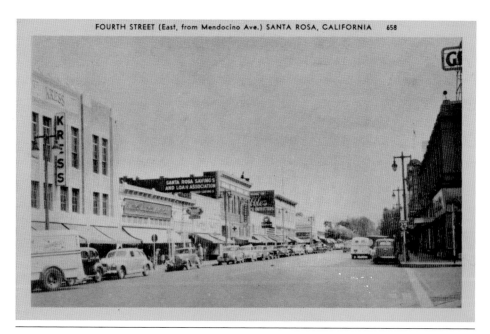

Cars line Fourth Street in this 1940s view looking east from the courthouse at Hinton Avenue. The Kress building provides an easy marker by which to compare the old and new images. At the right-hand side of the image above, the "G" can just be seen in a prominently displayed Grace Brothers Beer sign at the top of the building. The side of a building on the left advertises Dibbles Women's Outfitters. (Courtesy Sonoma County Museum.)

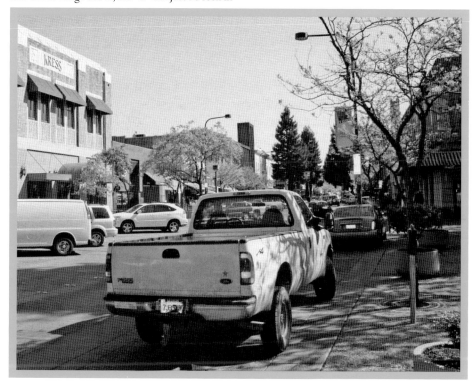

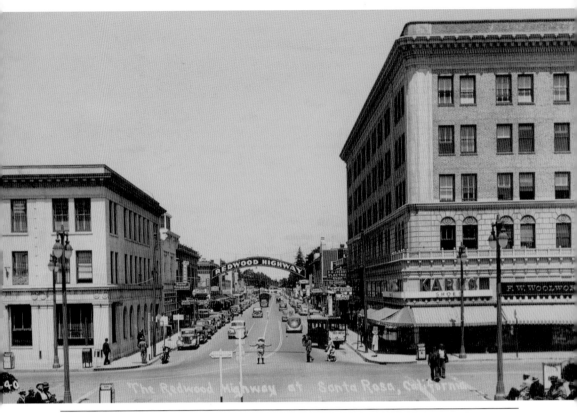

A policeman directs traffic at the corner of Mendocino Avenue and Fourth Street in this 1940s view from the courthouse looking north. Overarching the road is the Redwood Highway sign, marking the route that opened to some fanfare in 1924, drawing travelers north. A significant change for Santa Rosa occurred in 1949 when the Highway 101 bypass rerouted the old highway that coursed through the city center. On the right is the Rosenberg Building, virtually unchanged in the two images. The Rosenberg Building was built by Fred Rosenberg and his father, Max, a Santa Rosa businessman and store owner who opened his first Santa Rosa retail venture in 1896. On the left of both images is the Exchange Bank, which has occupied this site for over a century. (Courtesy Sonoma County Museum.)

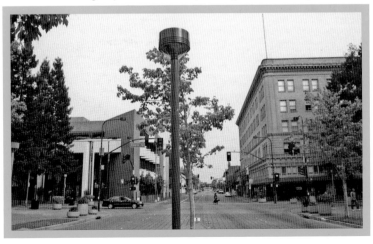

AROUND THE SQUARE: THE HEART OF SANTA ROSA

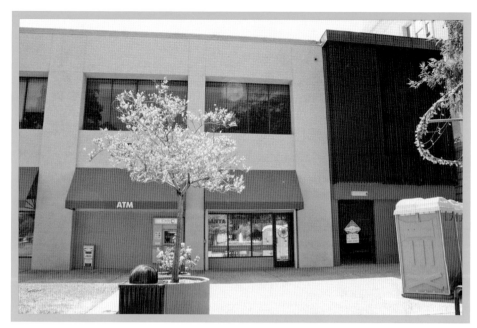

Eisenhood's, on the west side of the courthouse, was one of several popular restaurants in post–World War II Santa Rosa. The Topaz Room, its counterpart on the opposite side of the courthouse, was perhaps the fanciest restaurant in town, but Eisenhood's also served fine fare to the growing numbers of Santa Rosa residents and visitors looking for an evening out. Eisenhood's sat on Exchange Avenue, which no longer exists. The site, which currently houses a police substation, looks out onto Courthouse Square. (Courtesy Gaye and John LeBaron collection.)

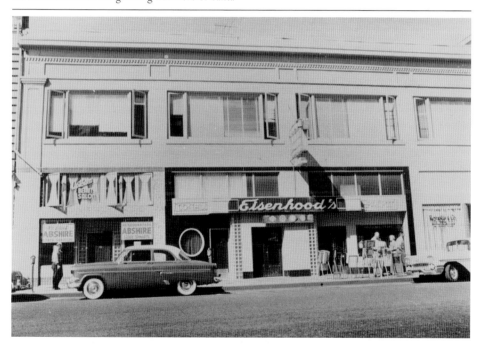

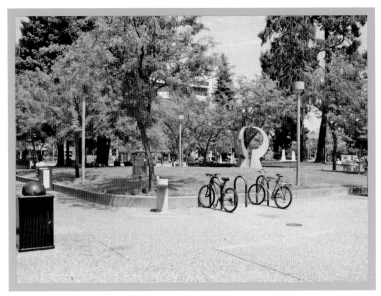

The 1884 courthouse that collapsed in the 1906 earthquake was replaced in 1910 with the stately structure pictured here *c.* 1949. Looking southeast across the front of the courthouse, the view below is taken from Fourth Street and what was Exchange Avenue. The courthouse was determined to be unsafe and demolished in 1965. The loss of the building is a tale of lament often told by longtime Santa Rosa residents, many of whom doubt the claim that the courthouse was structurally unsound. Today the same view shows Courthouse Square. (Courtesy Sonoma County Museum.)

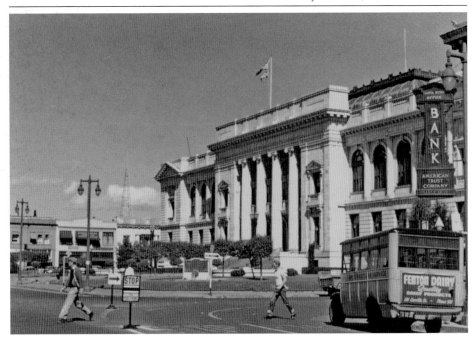

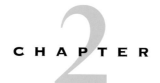

STREETS AND HOMES

EXPLORING THE

NEIGHBORHOODS

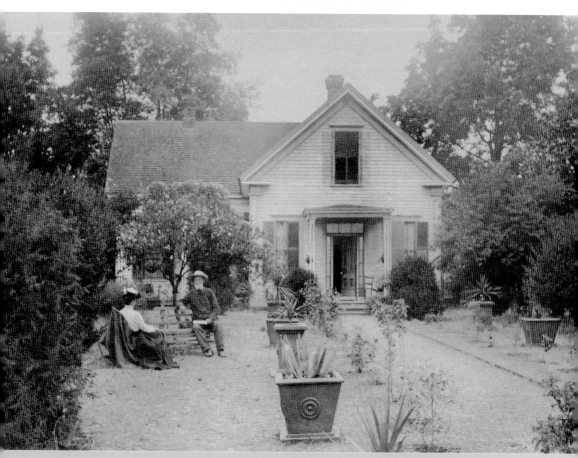

Santa Rosa has had many grand, historic homes, yet perhaps more representative of Santa Rosa is the simple home of a farmer, like that of Charles Range pictured here. After all, farmers were the backbone of the town for much of its history. Range's home sat at the north end of Santa Rosa, well beyond the boundaries of the city at the time it was built around the 1870s. Today this location is along Range Avenue where Coddingtown Mall is now located. (Courtesy Sonoma County Museum.)

The image above was taken April 1, 1916, at Santa Rosa's first-ever Safety First Day. Perhaps it was also the last Safety First Day, but the photograph shows Fourth Street near the intersection with Pierce Street on the far left. It also provides a glimpse of the city's important figures of the day, including Luther Burbank and Sen. Herbert Slater, seated together in the back of the car. The home of Frank Doyle, president of the Exchange Bank, can be seen to the rear left. While some older homes remain near this intersection, most of what was then an upper-end residential area has been taken over by stores and businesses spreading out from the downtown core over the years. (Courtesy Sonoma County Museum.)

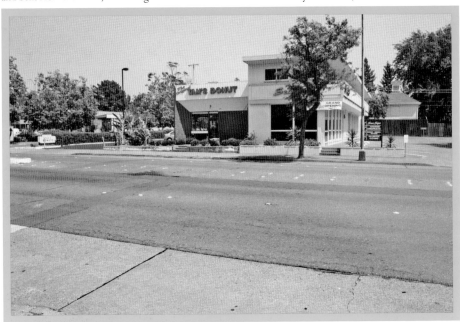

STREETS AND HOMES: EXPLORING THE NEIGHBORHOODS

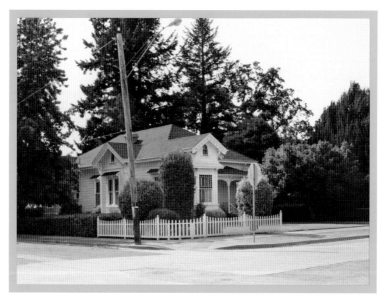

Somewhat smaller than many of the mansions and other historic homes on McDonald Avenue, the Wright home sits at the corner of McDonald Avenue and Thirteenth Street. Looking much as it did in this image taken in the 1880s, the home was in McDonald's Addition, the section of Santa Rosa for the well-to-do of the 19th century, including several merchants, doctors, attorneys, bankers, and politicians. The Wright home belonged to A. S. Wright, a physician. (Courtesy Gaye and John LeBaron collection.)

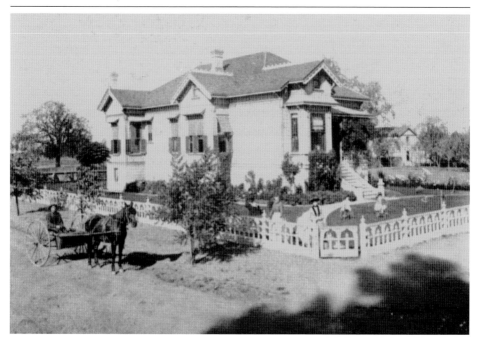

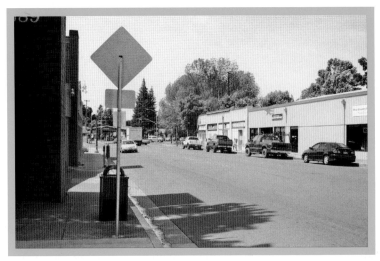

This view north along Mendocino Avenue is near the intersection with Cherry Street. The historic view shows the corner of a nice home and a palm tree–lined avenue. The houses and neighborhoods past Fifth Street heading north were considered among the most desirable residential areas of Santa Rosa in the 19th and first part of the 20th centuries. Today the stretch of road is a bit of a ramshackle mix of bars, stores, and a few elements of old Santa Rosa, including the nearby Church of Incarnation. (Courtesy Sonoma County Museum.)

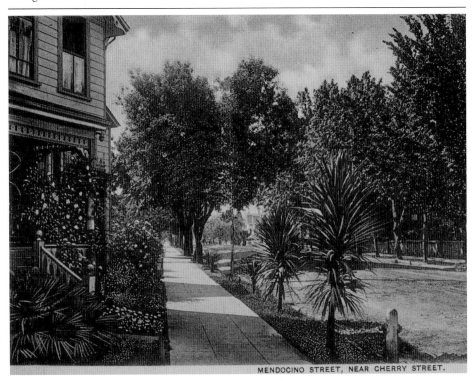

MENDOCINO STREET, NEAR CHERRY STREET.

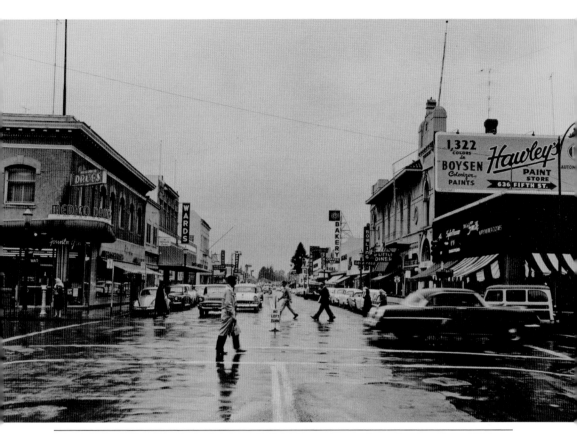

The view above of Mendocino Avenue in 1958 looks north from Fifth Street. Santa Rosa was once the home of several significant buildings with impressive ballrooms, ornate architecture, and cloistered meeting rooms. Devoted to a variety of fraternal orders, the buildings served various functions, including mysterious rites performed by men in unusual costumes. The Native Sons of the Golden West building, on the right in these images, is the only remaining example. (Photograph by Don Meacham; courtesy Sonoma County Library.)

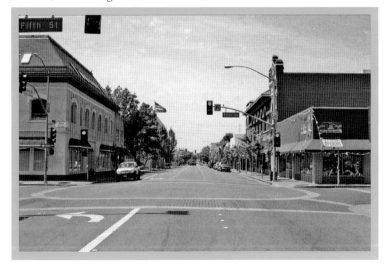

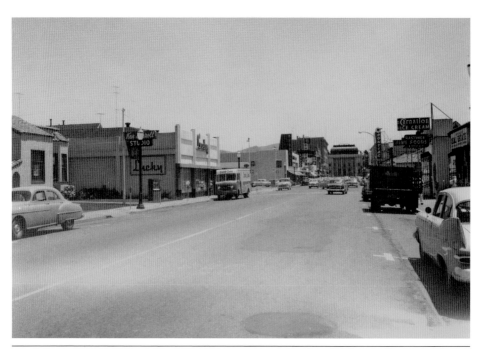

Looking south along Mendocino Avenue, the 1960 photograph above shows the courthouse at the end of the vista. The Rosenberg Building remains recognizable on the left in both images, but the contemporary photograph below shows a tree-lined Mendocino Avenue and no courthouse in the distance. The earlier image shows virtually no vegetation and a different sort of mix of businesses, including Lucky Grocery Store and the Carnation Ice Cream Shop. (Courtesy Sonoma County Library.)

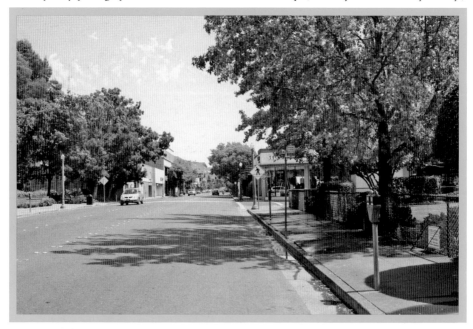

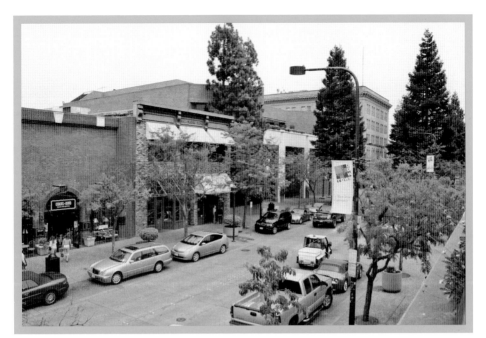

The elevated perspective below of Fourth Street, looking east, was taken in 1945 during a World War II war bond rally and parade. The image provides an unobstructed view down Santa Rosa's main east-to-west artery and central downtown area. In comparison to the contemporary image, the most notable difference is the sheer quantity of trees that have grown up in downtown Santa Rosa. In fact, Santa Rosa, according to one count, has more trees per capita than any other city in the country. (Courtesy Sonoma County Museum.)

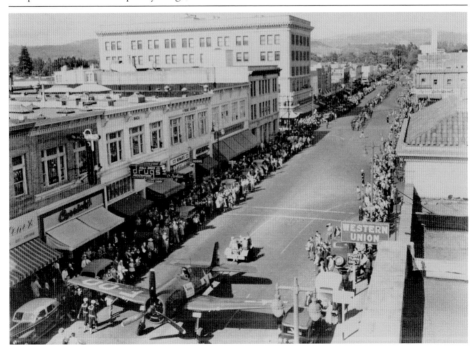

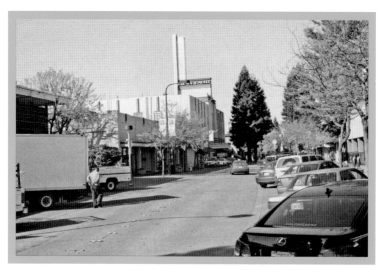

The image below looking west along Fourth Street shows Rosenberg's Department Store in its second location. Rosenberg's burned down in the 1930s, but Max Rosenburg and his son Fred managed to build the new art deco structure despite still being in the throes of the Depression. The prominent building remains standing today through the efforts of the Sonoma County Historical Society, which prevented its demolition in 1993. The carefully preserved structure is now occupied by a Barnes and Noble bookstore. (Courtesy Sonoma County Museum.)

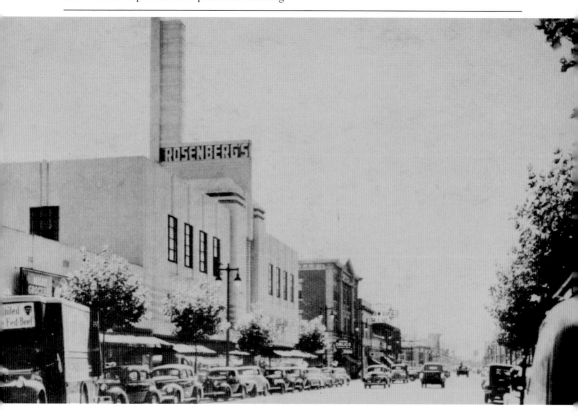

STREETS AND HOMES: EXPLORING THE NEIGHBORHOODS

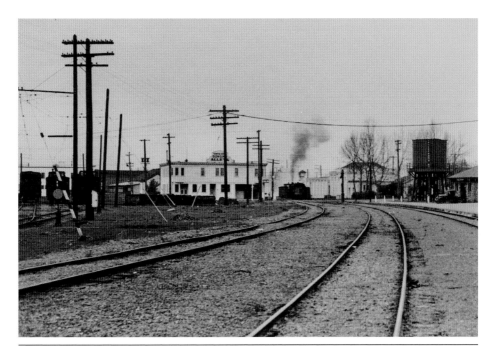

Looking north along the railroad tracks near the Northwestern Pacific Railroad Depot, the view shows some of the businesses on Sixth Street as the train moves between the buildings in the distance. A bowling alley is on the left and the old flour mill is on the right. A portion of the flour mill still stands, visible in the contemporary image below on the right. (Courtesy Sonoma County Library.)

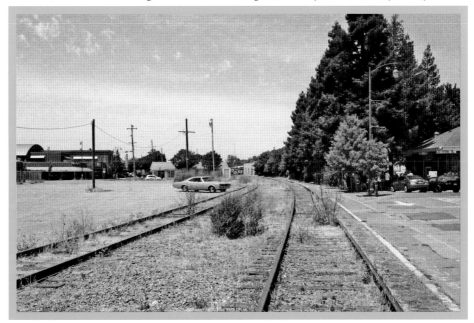

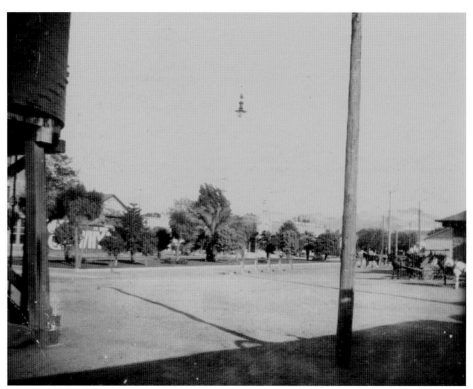

Taken from the train depot, the photograph from 1908 shows Wilson Street looking southeast toward Fourth Street. Obscured by the trees that front the depot property, the businesses along Wilson Street included a planing mill, a saloon, and the landmark Hotel La Rose, which is still in operation. (Courtesy Sonoma County Library.)

STREETS AND HOMES: EXPLORING THE NEIGHBORHOODS

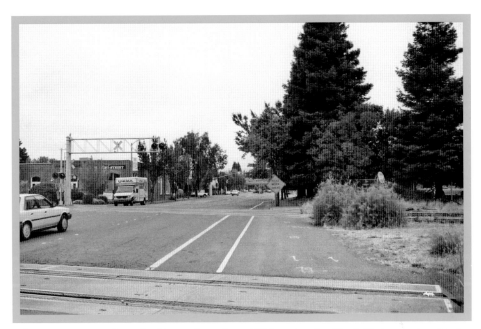

Below is a view east along Third Street from the railroad tracks. Opened near the tracks in 1912, Mead-Clark Lumber was one of several dealers in construction materials that took advantage of growth in Santa Rosa in the decades following the 1906 earthquake. Mead-Clark moved, and today, beyond the trees on the right in the image above, is the Courtyard Marriott Hotel. (Courtesy Sonoma County Library.)

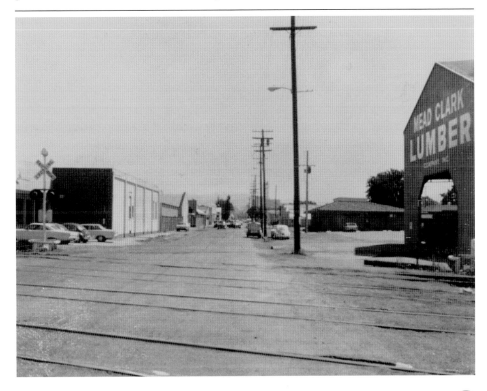

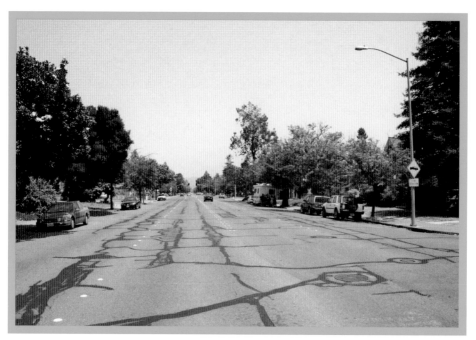

The view above is facing east along Sonoma Avenue. In the early years, Sonoma Avenue stretched out of the boundaries of Santa Rosa into Farmer's Addition, with larger lots and agricultural land. By the time the early-20th-century photograph below was recorded, Sonoma Avenue had been lined with trees, and some larger homes had been constructed along the road. (Courtesy Sonoma County Museum.)

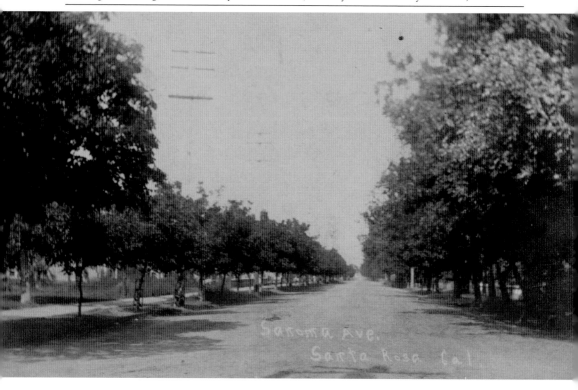

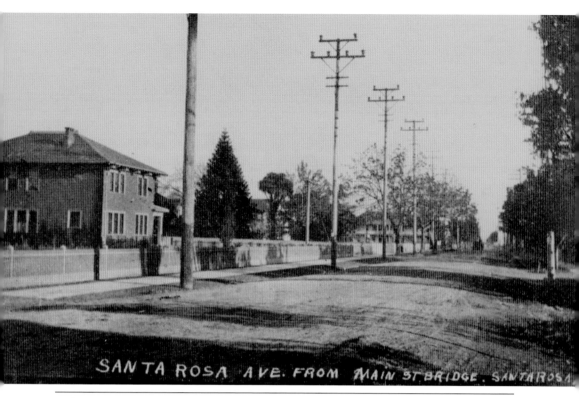

SANTA ROSA AVE. FROM MAIN ST BRIDGE. SANTA ROSA

Looking south from the Main Street bridge, Luther Burbank's second Santa Rosa home is visible on the left of the historic image above taken around 1915. Main Street is now Santa Rosa Avenue, and city hall dominates the area Burbank's home once occupied. Of course, Burbank's original home and gardens are preserved a little farther down the road, not quite visible through the trees in either the historic or the contemporary image. (Courtesy Sonoma County Museum.)

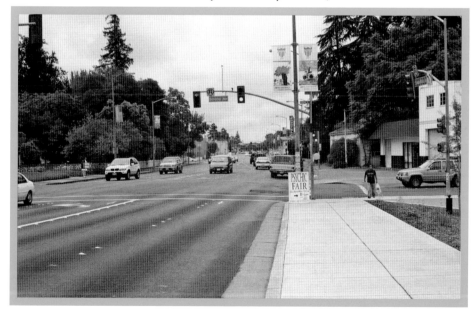

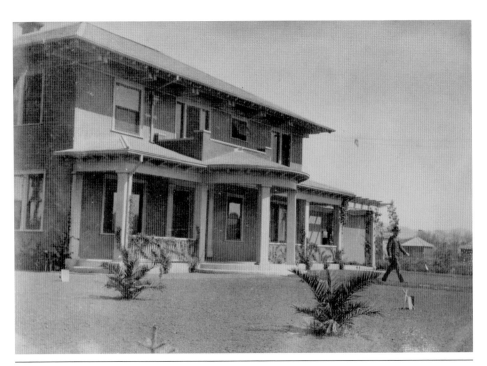

Luther Burbank is seen above emerging from his home one afternoon around 1912. The photograph was taken by Claude Sanborn, an amateur photographer who created a rather memorable collection of images of Santa Rosa and other parts of Sonoma County. Apparently this day he snatched a shot of Santa Rosa's biggest celebrity, the world-renowned horticulturalist Luther Burbank. While Burbank's older Santa Rosa home, garden, and greenhouse are preserved just south of this site, the home pictured here was demolished, and the lot is now part of the Santa Rosa City Hall complex. (Photograph by Claude Sanborn; courtesy Sonoma County Museum.)

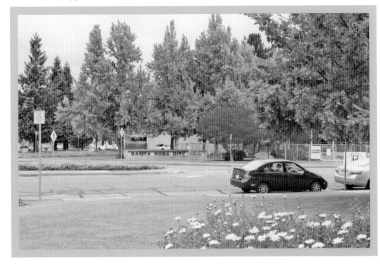

The home below at 311 Elliott Avenue originally belonged to Fr. John M. Cassin, the pastor of Saint Rose Church. Cassin is pictured here in his buggy in front of the house, which he sold to the Van Wormer family, who are seated on the porch in the historic image taken in December 1901. Today the site of the Van Wormer home is part of the Santa Rosa Junior College campus, which was established at its current location in the 1930s. Some homes remain along Elliott Avenue, but many gave way to the expansion of the junior college. (Courtesy Sonoma County Museum.)

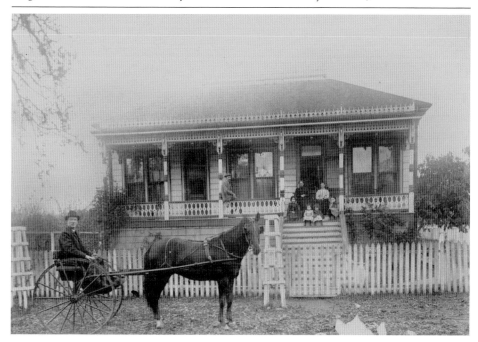

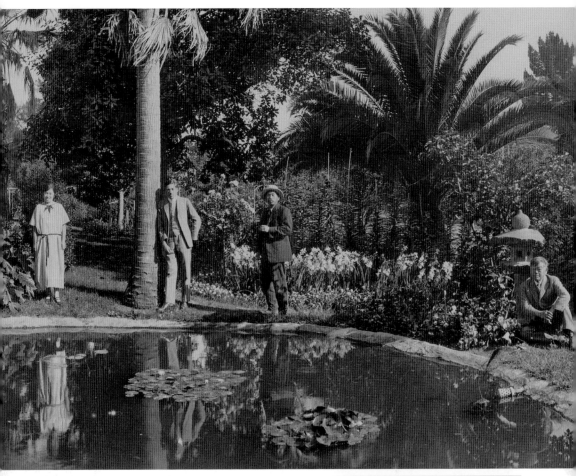

The lush garden and pond pictured above were situated outside the manor house at Fountaingrove at the north end of Santa Rosa. The photograph dates to about 1932 and shows the owner, Kanaye Nagasawa, second from the right, along with some family members. Nagasawa, one of the first Japanese to ever enter the United States, came to Santa Rosa with a religious community in 1875 and eventually ran Fountaingrove Winery with great success. Nagasawa faced financial difficulties toward the end of his life and most of the property was sold off to cover debts. At its peak, however, the Fountaingrove estate held some of the most opulent and lavishly landscaped residences in or near Santa Rosa. Today a hotel, businesses, and other development surround the empty lot pictured at right.

TRANSPORTATION

RUTS, RAILS, AND ROADS

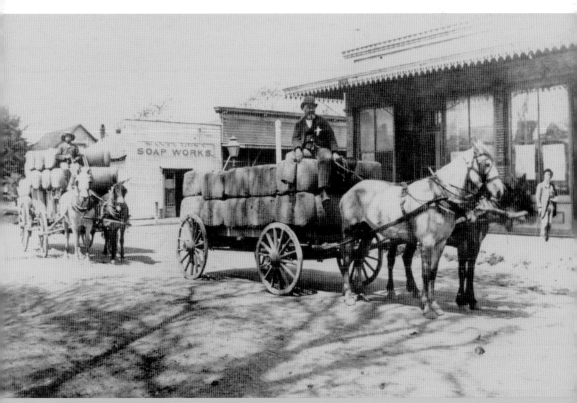

Here are two wagons filled with bales of hops. Not exactly transportation at its most transformative, yet it was the movement of crops to market that shaped the town of Santa Rosa, justifying the presence of three major rail lines and bringing in the money to develop the town. Frank Goodman is shown here, seated on top of his hops bales with reins held loosely in his left hand, at the corner of Third and B Streets in 1877. (Courtesy Sonoma County Museum.)

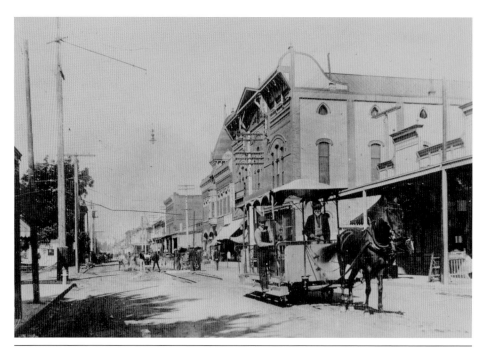

The early photograph above, looking west along Fourth Street, shows a horse-drawn streetcar and a work crew repairing the rails in the background. The horse-drawn streetcars were replaced by an electric version not long before the 1906 earthquake. Today there are only cars. The loss of rail service and good public transportation is today the source of some frustration. (Courtesy Sonoma County Museum.)

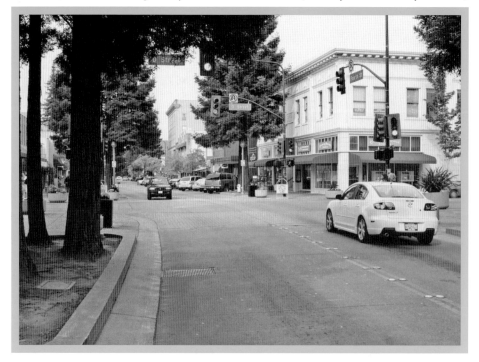

TRANSPORTATION: RUTS, RAILS, AND ROADS

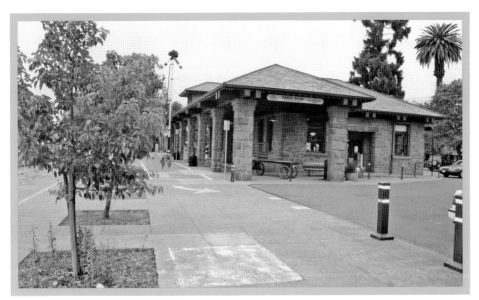

The Northwestern Pacific Railroad depot pictured below was built after the 1906 earthquake from locally quarried basalt stone. The NWP represented the consolidation of several railroad interests. The original line into Santa Rosa, from the Petaluma River, had been purchased by Southern Pacific, and other lines had been taken in under the umbrella of the Santa Fe Railroad Company. The interests collaborated to form the NWP in 1907, bringing passenger traffic into Santa Rosa to its peak, with multiple trains hauling day-trippers and others north from the Bay Area. The depot sits at the foot of Fourth Street, and once offered an easy shot for tourists straight to the heart of downtown. Today the depot is a visitor's center. (Courtesy Sonoma County Library.)

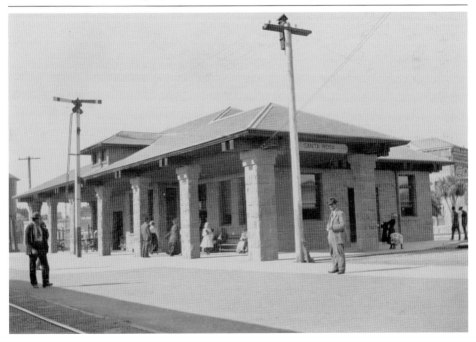

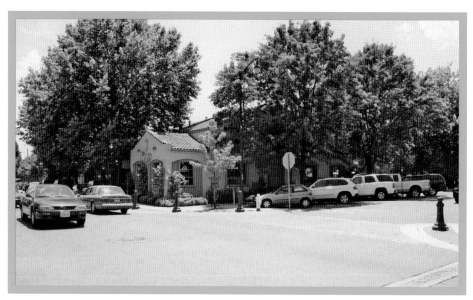

The image below from 1924 shows the Petaluma and Santa Rosa Railroad depot near the foot of Fourth Street. The P&SR provided reliable service via electric rail lines between various towns in Sonoma County beginning in 1903. The site is now Chevy's Restaurant in the Railroad Square historic district. (Courtesy Sonoma County Library.)

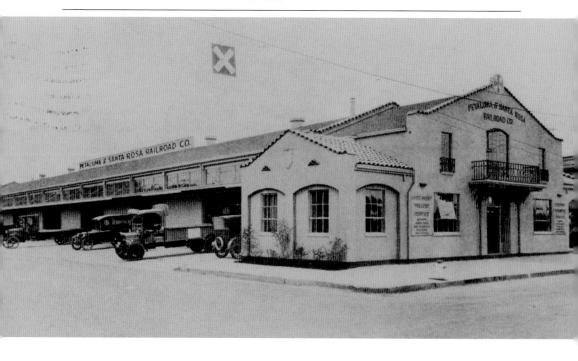

TRANSPORTATION: RUTS, RAILS, AND ROADS

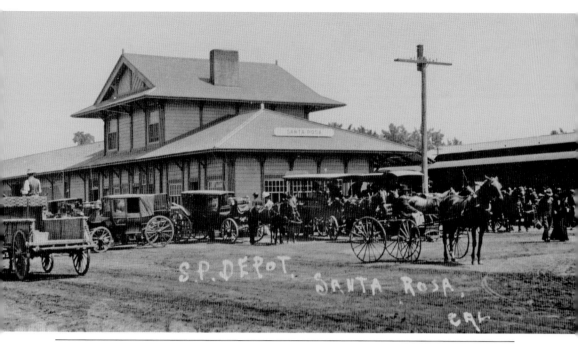

The Southern Pacific Depot on North Street sat between Benton and Fourteenth Streets. Local, well-connected fruit broker and developer Mark McDonald became involved in the promotion of an additional railroad line into Santa Rosa and had great influence over the rail route and placement of the depot. Not surprisingly, the arrangement favored McDonald's own enterprises. The depot was even conveniently located in proximity to his home on McDonald Avenue. Today the site on North Street still backs up to the ornate McDonald Avenue homes, but it is occupied by Bekins Movers and Storage. (Courtesy Gaye and John LeBaron collection.)

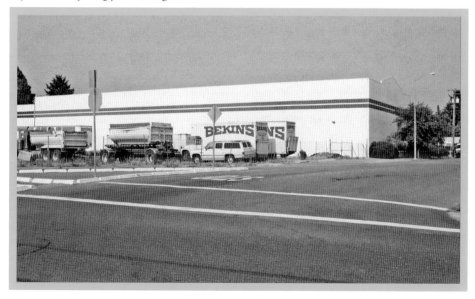

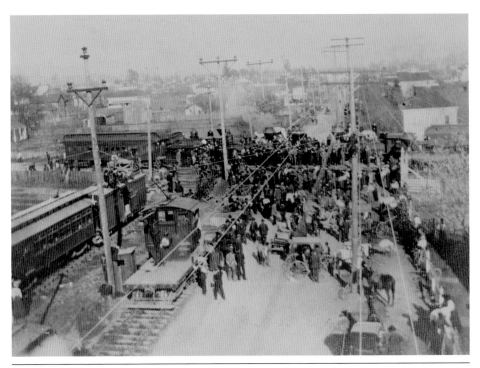

The historic photograph above shows Sebastopol Avenue where it crosses the railroad tracks between Roberts Road and Chesnut. Looking north, the 1905 photograph was taken during the so-called battle of Sebastopol Avenue. While multiple railroad lines had generally proved a boon to Santa Rosa, helping to establish the city as a shipping hub for agricultural products, competition between rail interests could be intense. Physical confrontation broke out when workers for the electric P&SR line sought to build a crossing of the main north-south tracks of the CNW line. Today the area in the western part of Santa Rosa is part of the predominantly Latino area of the city known as Roseland. (Courtesy Gaye and John LeBaron collection.)

TRANSPORTATION: RUTS, RAILS, AND ROADS

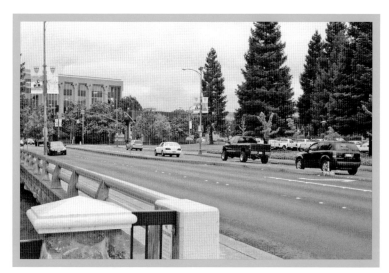

The iron bridge over Santa Rosa Creek, pictured below, opened for use in 1876. This image was taken decades later, as indicated by the sign that warns automobile drivers and bike riders to proceed no faster than the precise speed of "a walk." In the past several decades, Santa Rosa Creek had been virtually obliterated from the landscape by development. Today this spot is adjacent to the city hall complex. Recent efforts have been made to restore the creek as a recognizable feature in the urban landscape. (Courtesy Sonoma County Museum.)

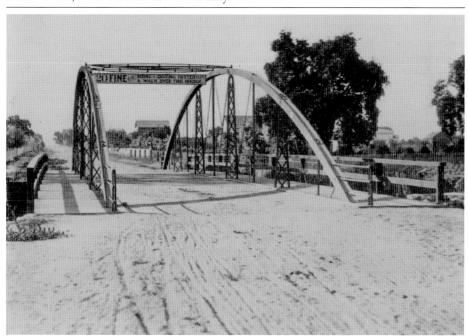

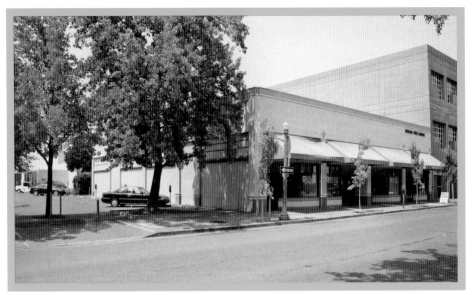

This view below of businesses along Fifth Street near B Street shows the Fifth Street Stables. This business was one of the few to last into the 1920s, when the automobile had gained prominence. Today this stretch of Fifth Street is occupied by a gym, a bookstore, and several other businesses. (Courtesy Gaye and John LeBaron collection.)

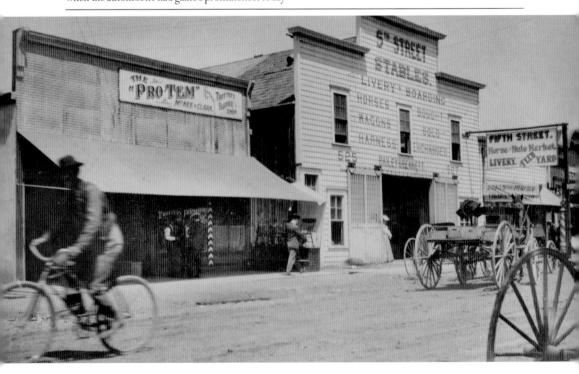

TRANSPORTATION: RUTS, RAILS, AND ROADS

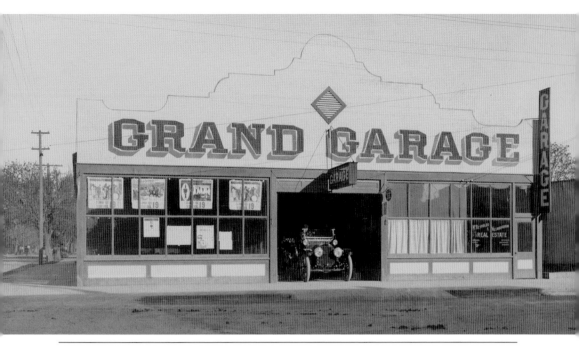

The Grand Garage (above) sat at the corner of Third and Main Streets in the early 20th century. The garage was an important Santa Rosa fixture for the dawning age of the automobile in Santa Rosa. Servicing cars by 1912, the Grand operated at a time when owning a car was still something of a novelty. The site, at Third Street and Santa Rosa Avenue, is occupied by Bank of America. (Courtesy Gaye and John LeBaron collection.)

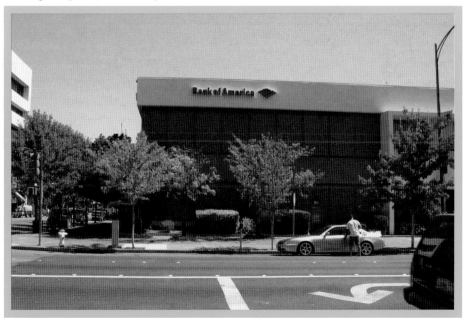

The image at right shows the Redwood Highway route as it appeared in the 1940s. This section is at the north end of Santa Rosa approaching the Fountaingrove area on the right. The Fountaingrove Round Barn is visible on the lower part of the hills, in the middle of the image. Today this is where Mendocino Avenue ends, either merging onto the 101 Freeway or turning onto the old Redwood Highway as it continues on into the communities of Larkfield and Wikiup. It almost goes without saying that the change from the Redwood Highway to the 101 corridor has led to changes in Santa Rosa. Also, while not quite visible over the trees in this contemporary image, transformation of the Fountaingrove ridgeline over the past two decades has been relatively swift and raised voices of concern over growth. (Courtesy Sonoma County Museum.)

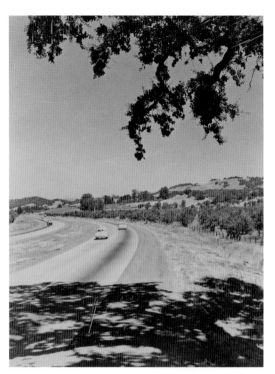

TRANSPORTATION: RUTS, RAILS, AND ROADS

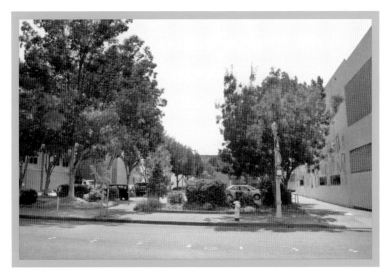

Redwood Rose Auto Center on Mendocino Avenue is shown in the image below from the 1930s. This was more than simply a gas station; travelers along the Redwood Highway could stop in for a root beer, a malted milk, a new set of tires, an oil change, a repair, or just a tankful of gas. This location would later be the Montgomery Ward building, and today it is the parking lot next to the *Press Democrat* newspaper building. (Courtesy Gaye and John LeBaron collection.)

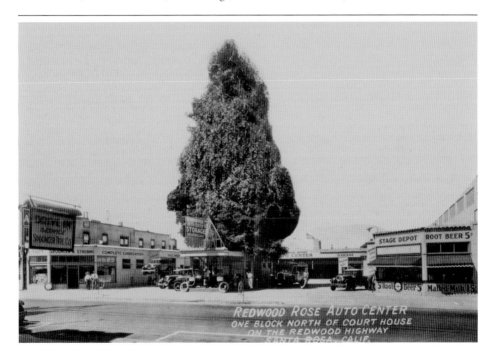

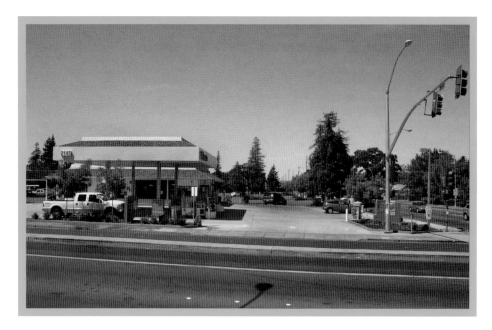

The 1930s image below shows the Santa Rosa Service Station and Auto Camp at the corner of Mendocino Avenue and Steele Lane. The auto camp represents the growing importance of the automobile in Santa Rosa as garages, service stations, and dealerships sprouted up across the city in the 1910s and 1920s. The "camp" provided a stop along the Redwood Highway for the growing number of tourists traveling by automobile. The corner of Steele Lane and Mendocino Avenue is now the home of a Chevron gas station that does not offer amenities for overnight visitors.

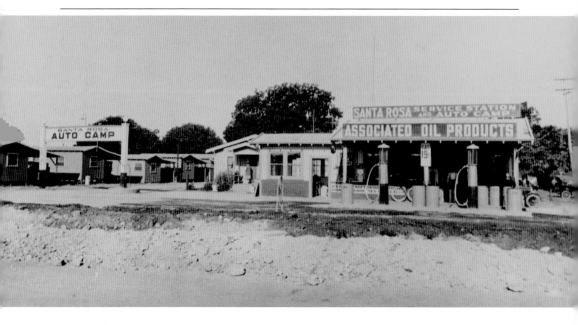

TRANSPORTATION: RUTS, RAILS, AND ROADS

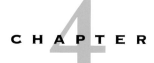
HOUSES OF MIND AND SPIRIT

CHURCHES AND PLACESOF LEARNING

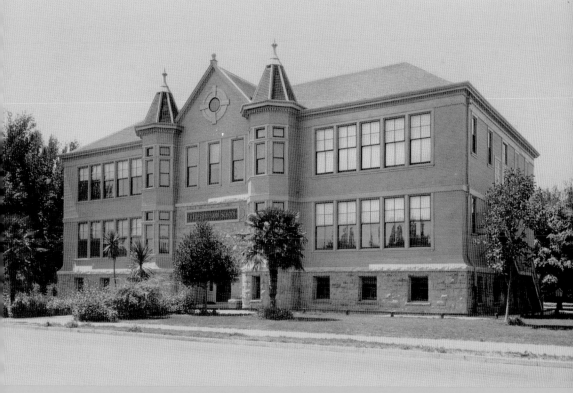

One of just a few public elementary schools in Santa Rosa at the end of the 19th century, Luther Burbank Elementary School sat on A Street near Second. Burbank Elementary School currently occupies a similar location near Juilliard Park, where in years past horticulturalist Luther Burbank conducted many of his experiments with plants. (Courtesy Sonoma County Museum.)

The First Christian Church was built on Ross Street in 1896. The church and its congregation evolved from the Disciples of Christ, whose gatherings began in 1854 in the short-lived town of Franklin that preceded the founding of Santa Rosa. They had one of the first two churches in Santa Rosa. The disciples eventually moved to the church on Ross Street, which became the Christian church. Today Ross Street does not boast any buildings quite so grand. (Courtesy Sonoma County Museum.)

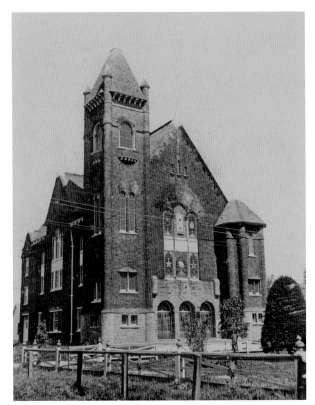

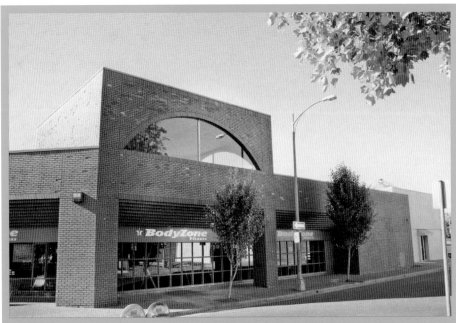

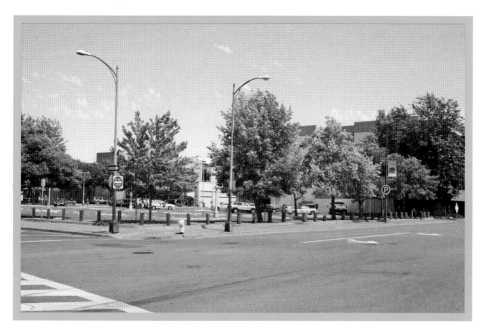

At times, Santa Rosa has seemed enamored with the concept of relocating its historic structures in order to save them. Pictured below is the Church of One Tree, edified in one of cartoonist Robert Ripley's famous "Believe It or Not" newspaper features. Constructed in 1873 from one 275-foot redwood tree, it served as the First Baptist Church at Fifth and Ross Streets. In 1957, the City of Santa Rosa purchased the building, eventually moving it to Juilliard Park where it sits today. (Courtesy Sonoma County Museum.)

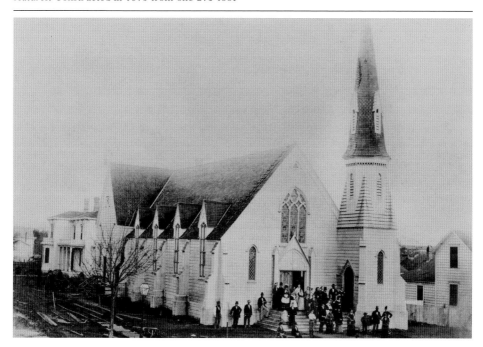

HOUSES OF MIND AND SPIRIT: CHURCHES AND PLACES OF LEARNING

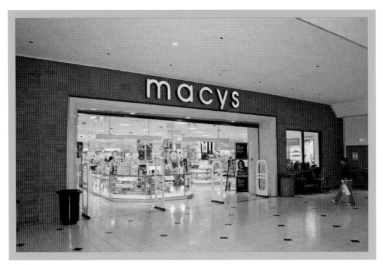

The relatively modest Latter-day Saints church pictured below sat on Fifth Street. After the 1906 earthquake, the church served as a relief center for Santa Rosa residents, who are shown waiting in line in this image taken in the days immediately following the disastrous quake. Today this site is within the Santa Rosa Plaza mall, near the entrance to Macy's. (Courtesy Sonoma County Museum.)

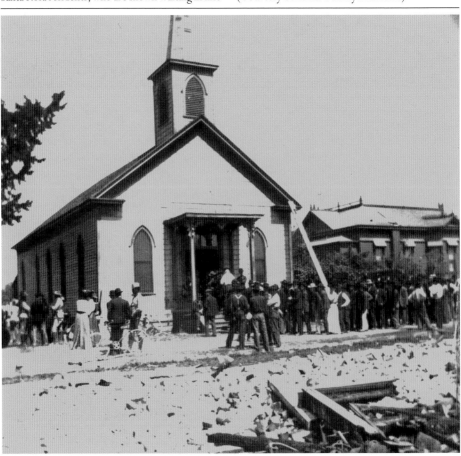

HOUSES OF MIND AND SPIRIT: CHURCHES AND PLACES OF LEARNING

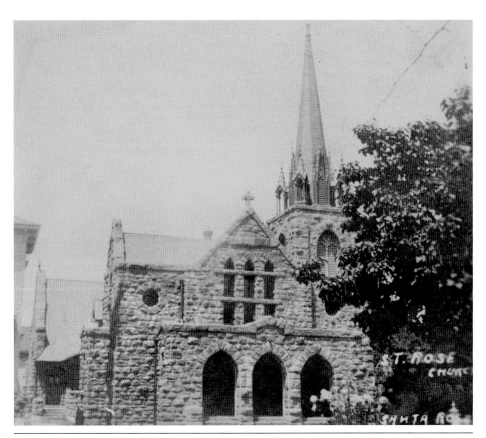

St. Rose Roman Catholic Church, pictured above, was constructed on B Street near Seventh in 1900. The St. Rose parish, established in 1876, was named for Saint Rose de Lima, the namesake of Santa Rosa. Fr. John Cassin served as the church's pastor at the time of the construction of the stone church. The church weathered the 1906 earthquake with relatively little damage. As the modern image below shows, however, it was eventually modified and the steeple removed. (Courtesy Sonoma County Museum.)

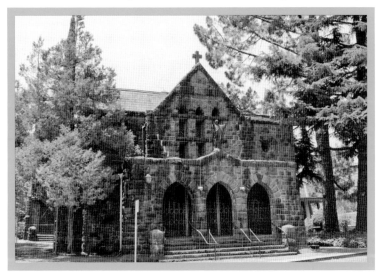

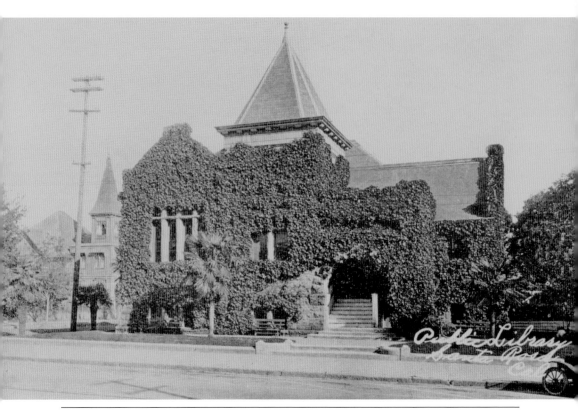

The Santa Rosa Public Library at Fourth and E Streets, pictured above, was the result of a grant from the Carnegie Corporation. Santa Rosa received $20,000 in 1902 and the Romanesque stone building opened in 1904. Only two years later, the building was severely damaged in the 1906 earthquake, but Carnegie provided some funds for repairs. The stone structure was replaced with a new library building in 1967, but one original stone wall was preserved on the east side of the new building, which is now the main branch of the Sonoma County Library. (Courtesy Sonoma County Museum.)

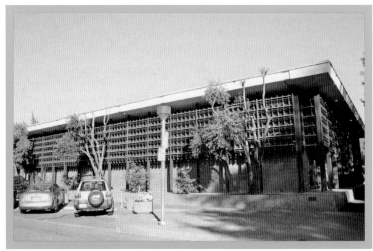

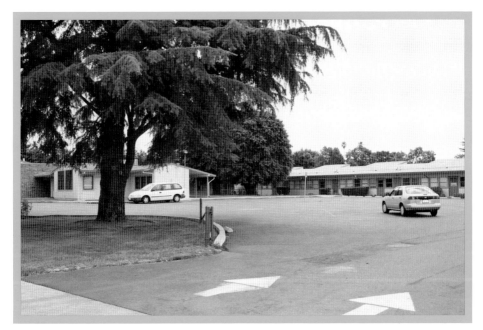

The Roseland School District formed in the 1800s, and Roseland School is pictured below in 1947. The district had financial troubles in the early 1900s due to low student-body population and low-assessed values on the western side of Santa Rosa. Today Roseland Elementary is in the heart of Santa Rosa's rapidly growing Latino area. The Roseland neighborhoods face problems similar to the early school district, as the City of Santa Rosa today is having difficulty overcoming financial problems in annexing the Roseland area. (Courtesy Sonoma County Library.)

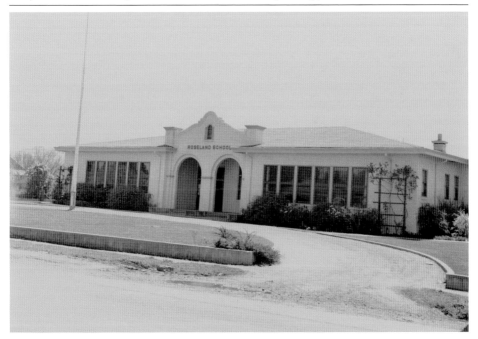

Santa Rosa High School opened in 1878, initially sharing Fourth Street School with lower grades. The Santa Rosa High School building illustrated below was constructed in 1895 at Humboldt and Benton Streets, but it burned down in 1921. Currently a private school, seen above, occupies the site. (Courtesy Sonoma County Museum.)

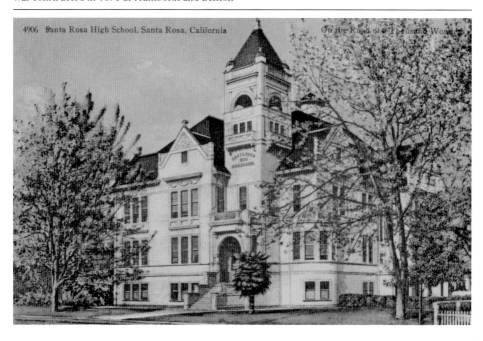

4906 Santa Rosa High School, Santa Rosa, California On the Road of a Thousand Wonders

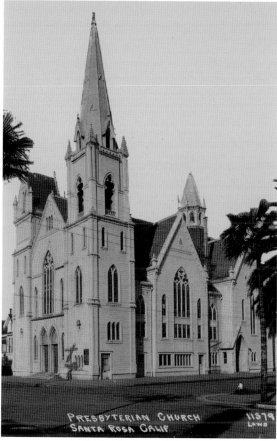

PRESBYTERIAN CHURCH
SANTA ROSA CALIF

11879
Laws

Pictured at left, the Gothic-style First Presbyterian Church sat at the corner of Johnson and Humboldt Streets, which today is the corner of Humboldt and Seventh Streets. The Presbyterian church held its first services in 1855 and built a church at Fifth and Humboldt in 1869. The church in the image at left was built in 1891 for a cost of $18,000. Today the site provides additional parking for employees of the *Press Democrat* newspaper. (Courtesy Sonoma County Museum.)

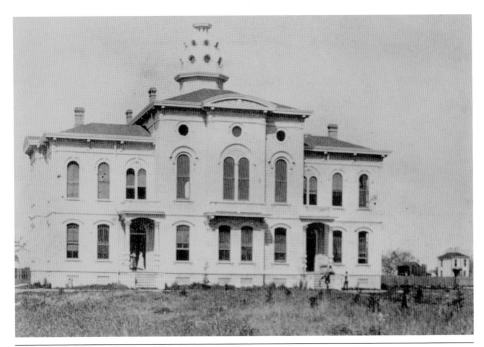

The Christian College, pictured above, was built in 1872 near B and Tenth Streets. Along with Pacific Methodist College, it lent Santa Rosa an air of sophistication and learning at a time when the town still looked a lot like the frontier. In 1880, the Italianate building with its distinctive cupola was purchased by the Ursuline nuns and converted into a convent. Today it remains part of the Catholic complex of buildings near St. Rose Church.

BUSINESSES
FROM FINE DINING
TO A HARD DAY'S LABOR

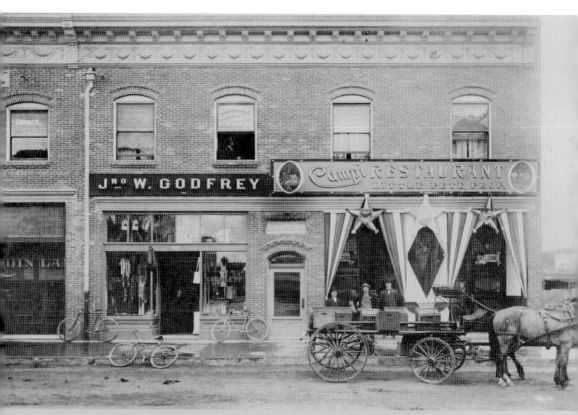

The Campi Restaurant, on the south side of Third Street facing the courthouse, had a few rooms for lodging upstairs. While not nearly as large as some of the other Italian-owned hotel-restaurants in Santa Rosa, the Campi was a popular eatery serving residents and travelers, such as merchants, hops brokers, and traveling business people. (Courtesy Sonoma County Museum.)

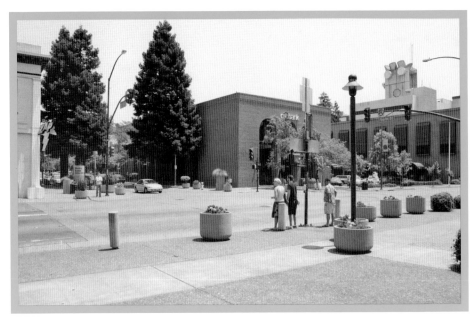

The view down B Street below shows a man happily lounging in a carriage. Behind him is the Overton, one of Santa Rosa's larger, earlier hotels. The Overton moved into a new building around 1911, which sat on a corner of Fourth and B Streets, opposite the Occidental Hotel. The Overton would later become the Santa Rosa Hotel, prior to being torn down. Occupying this stretch of B Street now are Citi Bank, Wells Fargo, and parking areas. (Photograph by Claude Sanborn; courtesy Sonoma County Museum.)

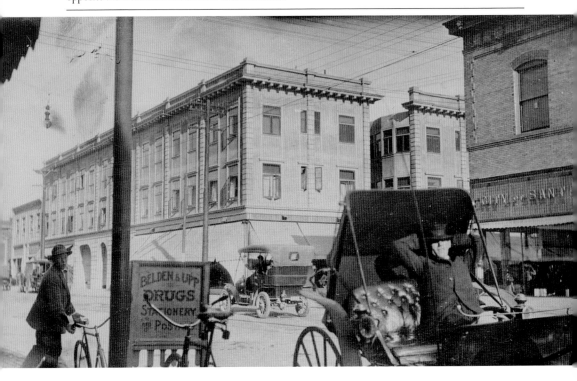

BUSINESSES: FROM FINE DINING TO A HARD DAY'S LABOR

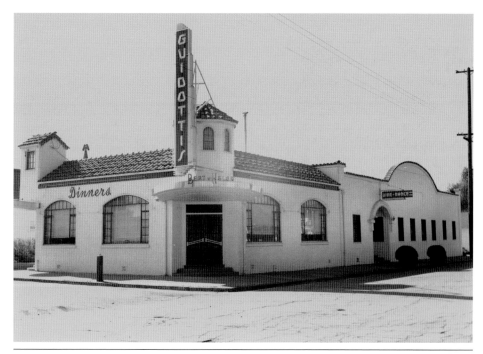

Originally the Toscano Hotel, owned by the Guidotti family, Guidotti's Restaurant was a popular eatery in the 1940s. The image above was taken in 1948. The building, located at the corner of Seventh Street and Adams Street, was taken over by Stark's Steak House in 2008, but looks much the same today as it did when Bert and Helen Guidotti served Italian fare to Santa Rosa's post–World War II diners. (Courtesy Sonoma County Library.)

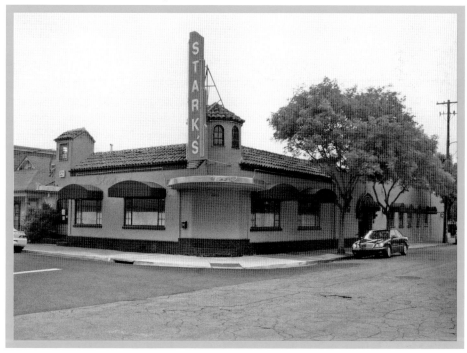

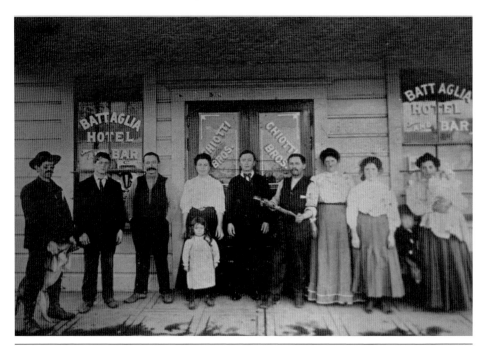

The Battaglia Hotel, pictured above, once occupied the corner of Adams and Sixth Streets near the railroad depot in Santa Rosa. Adams Street had several Italian hotels dating from the 19th century. The Battaglia, like several other Santa Rosa establishments in the railroad area, became the target of Prohibition raids in 1919. Lena Battaglia Bonfigli, the little girl posing with her family in the image above, would later change the name of the business to Lena's, which became a popular 1940s restaurant. Today the Chops Teen Center is on the same corner. The center was created through the legacy of Charles "Chop" DeMeo, who left much of his estate to be used for the benefit of Santa Rosa youth. (Courtesy Sonoma County Museum.)

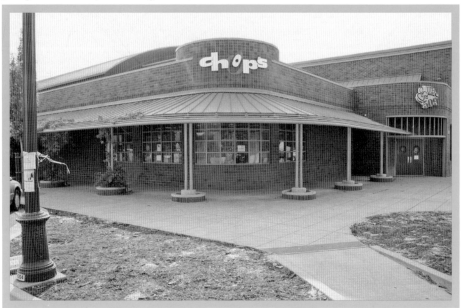

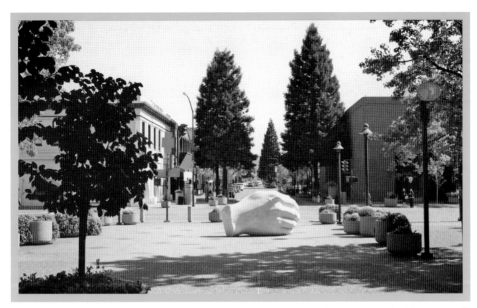

The view below, looking east along Fourth Street at B Street prior to 1920, shows the Occidental Hotel on the left and the Overton Hotel on the opposite corner. The contemporary image above is taken from the entry area of the Santa Rosa Plaza shopping mall. The enclosed mall, built in 1979, cuts across Fourth Street, the primary historic link between east and west Santa Rosa. (Courtesy Sonoma County Museum.)

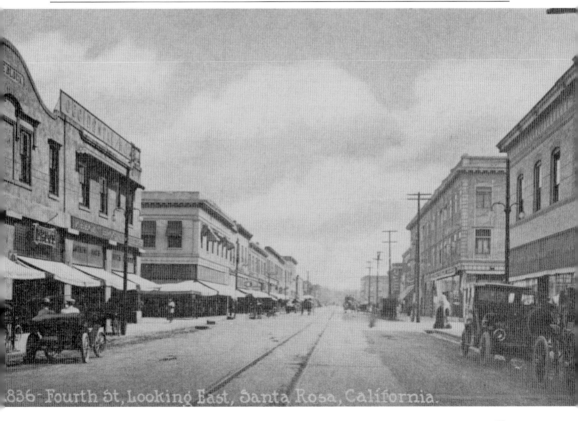

836-Fourth St, Looking East, Santa Rosa, California.

One of Santa Rosa's most renowned saloons, the Senate, is pictured below around 1910. Proprietor and town character Jake Luppold is shown third from left in the white coat. The Senate was located at 103 Main Street, south of the courthouse. Today the former site of the Senate is adjacent to the Santa Rosa Transit Mall. (Courtesy Sonoma County Museum.)

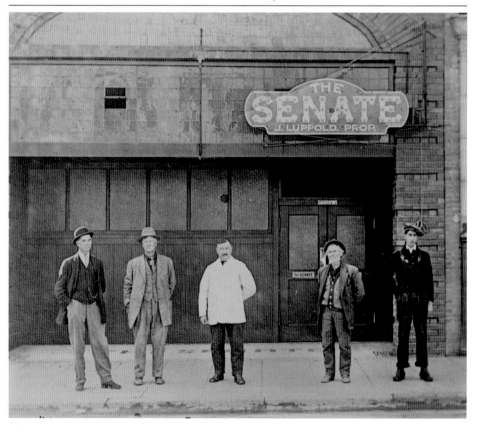

BUSINESSES: FROM FINE DINING TO A HARD DAY'S LABOR

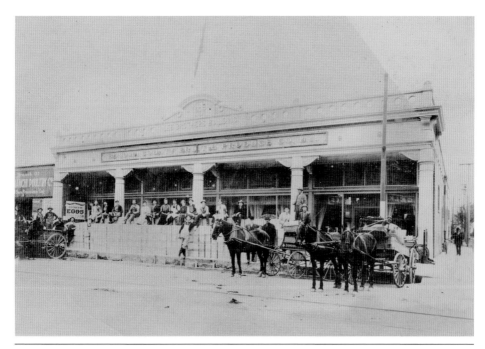

The Lee Brothers Building in the Railroad Square district was built in 1906 after the earthquake. The early photograph above shows the building occupied by the Sonoma County Fruit and Produce Company. Located near the town's Northwestern Pacific Railroad hub, many of the businesses in the area were associated with the agricultural industry that dominated the region. Today the railroad no longer runs, and the area is a historic district with antique stores, restaurants, and hotels. (Courtesy Sonoma County Museum.)

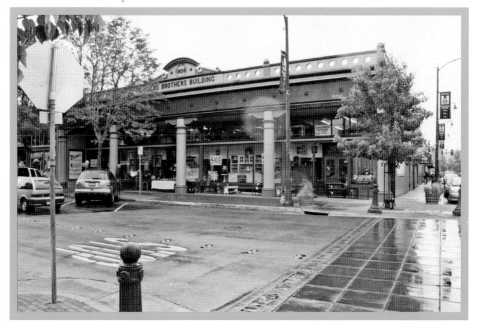

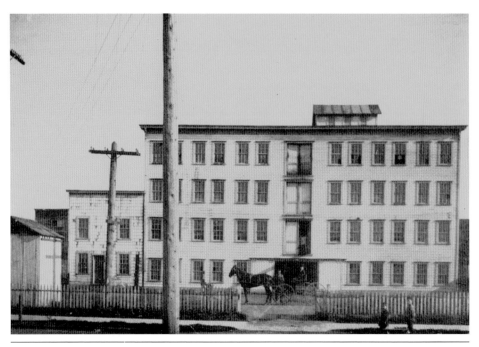

The Levin Tannery, pictured above, sat at the corner of Second Street and what was F Street. Today the 900 block of Second Street intersects with Brookwood Avenue. In the 1880s, the farm town of Santa Rosa began to take on a more commercial or light-industrial aspect. The tannery, which opened in the last quarter of the 19th century, was part of that evolution. Levin Tannery was not a favorite of local residents, who complained bitterly about the unpleasant odors. (Courtesy Sonoma County Museum.)

BUSINESSES: FROM FINE DINING TO A HARD DAY'S LABOR

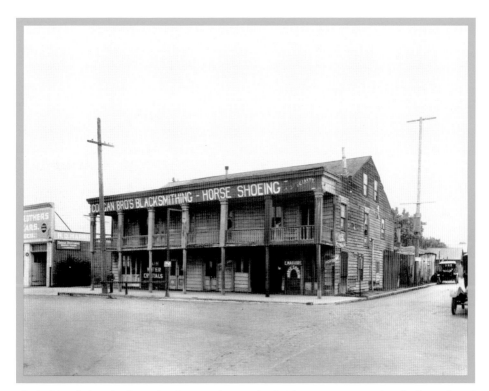

The building below that housed Colgan Brothers Blacksmithing played an important role in Santa Rosa. Built in 1855 by E. P. Colgan, it was originally the Santa Rosa House, a hotel and stagecoach stop in the very early days. Before the railroads, the Santa Rosa House represented the link to the world beyond the fledgling 1850s town, where both people and goods left or entered. Around 1910, it was converted into the blacksmith shop. Today the site at First Street and Santa Rosa Avenue (formerly Main Street) is Santa Rosa's city hall annex.

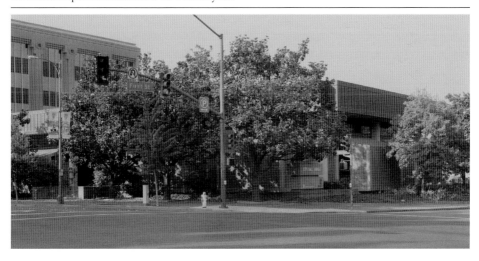

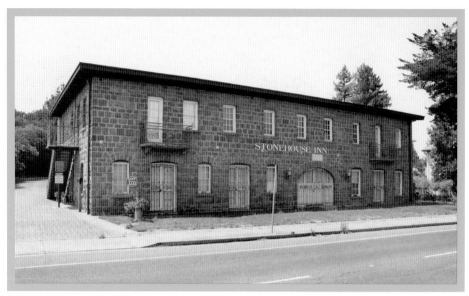

Santa Rosa's Stonehouse, pictured below along the Sonoma Highway, was built in 1909 by Italian stonemason Massimo Galeazzi as the Rincon Hotel. Galeazzi was involved in the building of many of Santa Rosa's historic basalt brick structures. The Stonehouse served as the Galeazzi home and as the Rincon Hotel. It was the target of Prohibition raids, as were most of the Italian restaurants and hotels in the area. The building went through several incarnations and today is the Stonehouse Inn, pictured above. (Courtesy Sonoma County Museum.)

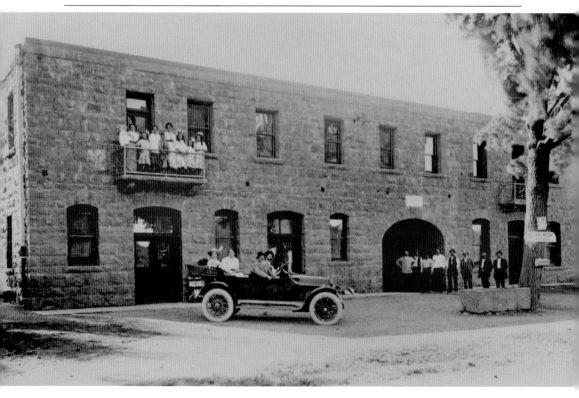

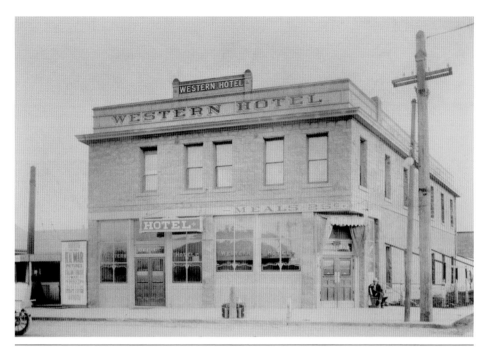

The Western Hotel, shown above in this historic image from about 1908, was constructed of locally quarried basalt stone around 1903. The building sits at the foot of Fourth Street and was once immediately adjacent to the P&SR electric rail depot. The hotel lost its entire eastern wall in the 1906 earthquake but was repaired and later expanded to offer more rooms. The early image shows the hotel prior to its expansion. Today the building shown below houses Flying Goat Coffee, J. Leonard Salon, and other businesses. (Courtesy Sonoma County Library.)

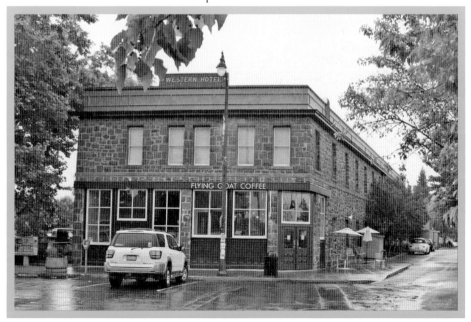

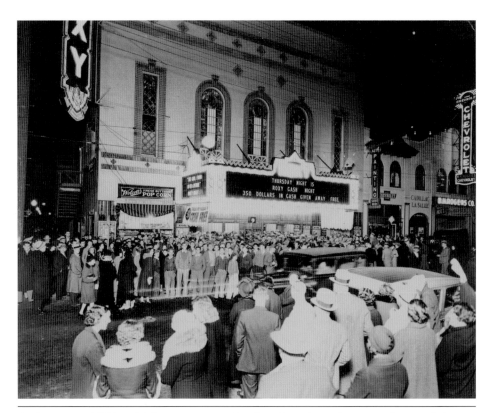

At the corner of Fifth and B Streets was one of Santa Rosa's most popular movie theatres, the Roxy, pictured above. A former vaudeville house and then the Cline Theatre, the building at Fifth and B Streets became the Roxy in the 1930s when it was exclusively devoted to showing film. The California, another popular movie house in Depression era Santa Rosa, boasted an organ that provided music during silent films. The Roxy's corner of Fifth and B no longer exists. Fifth Street was truncated at B Street by the construction of the Santa Rosa Plaza mall in 1979. A new Roxy multiplex theater opened at First and Santa Rosa Avenue in the early 2000s. (Courtesy Sonoma County Museum.)

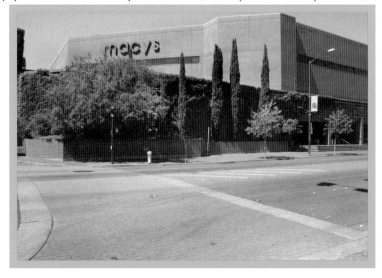

BUSINESSES: FROM FINE DINING TO A HARD DAY'S LABOR

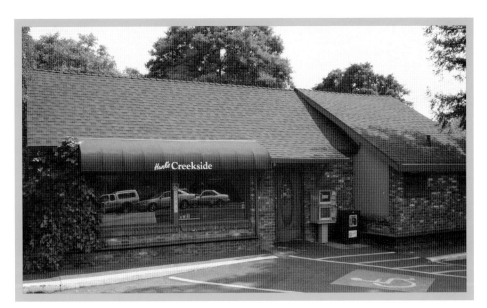

The image below of Clayt's Tavern, on Fourth Street near Farmer's Lane, was taken in the 1950s. Clayt's, so named for owner Clayt Williams, thrived in part on the business of sailors who were in Santa Rosa because of the reactivation of the Santa Rosa Naval Airfield in the lead up to the Korean War. Today that eastern part of Fourth Street is occupied by several businesses, including Hank's Creekside Café above. Hank's occupies the same building that started as the Old Trail Inn and later became Clayt's Tavern. All of the businesses on this stretch back up to Santa Rosa Creek. (Courtesy Gaye and John LeBaron collection.)

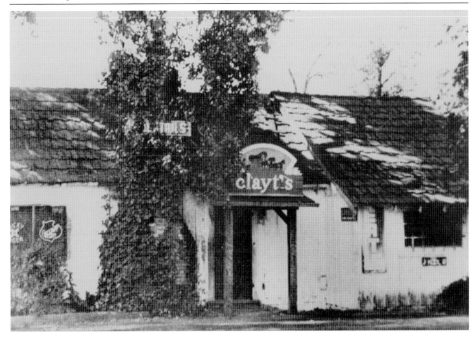

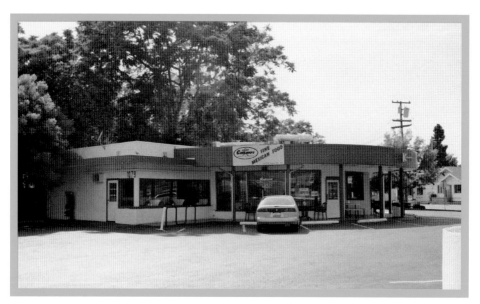

A quintessential car-culture hangout for teens and college students in postwar Santa Rosa, Quinley's Drive-In, pictured below, opened in 1947 at the intersection of Fourth Street and College Avenue and became Gordon's Drive-In in the early 1950s.

Despite the fervent, ongoing nostalgia for the days of cheap gas, roller-skating waitresses, and classic cars, the golden age of drive-ins has passed, and Quinley's is now Chelino's Mexican Restaurant, shown above. (Courtesy Gaye and John LeBaron collection.)

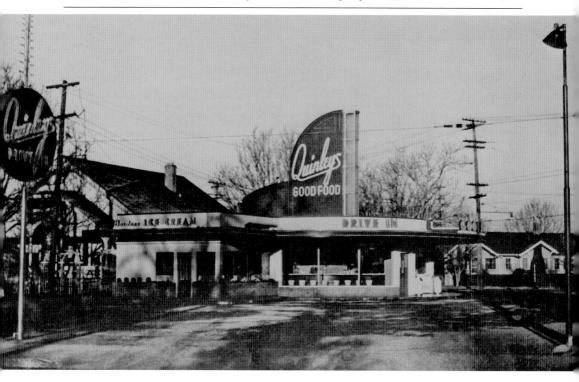

BUSINESSES: FROM FINE DINING TO A HARD DAY'S LABOR

AGENTS OF CHANGE
DEVELOPERS, QUAKES,
AND WARS

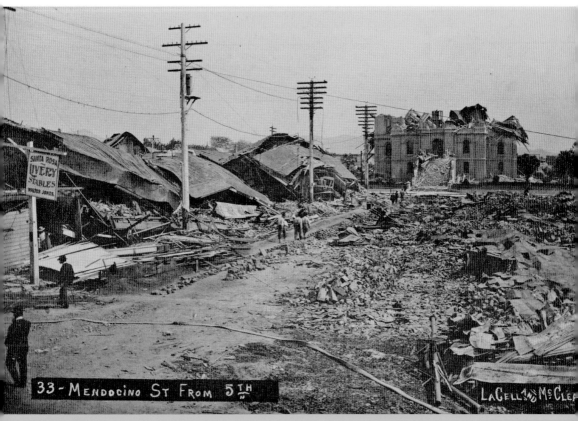

This view of the Sonoma County Courthouse and aftermath of the 1906 earthquake looks south along Mendocino Avenue. The destruction of Santa Rosa from the quake was thorough, with large swaths of the town either shaken to rubble or scorched by fire. More people died as a result of the quake—by percentage of the population—in Santa Rosa than were killed in San Francisco. The quake was a transformative event, an agent of change that would alter the city forever. (Courtesy Sonoma County Museum.)

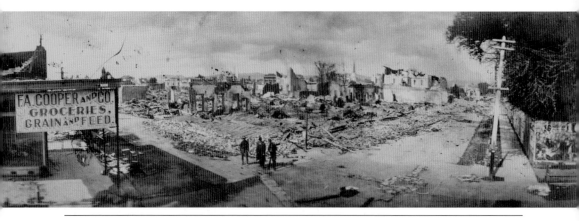

This early image above was taken in the aftermath of the earthquake on April 18, 1906. It shows the corner of Third and B Streets close to where it is generally suspected the ensuing fires began, in a grocery store or in the apartments above it. The 1906 earthquake completely devastated Santa Rosa, and the city that rose up out of the ashes would be significantly transformed. The contemporary image shows the same corner, dominated by Wells Fargo Bank. (Courtesy Sonoma County Museum.)

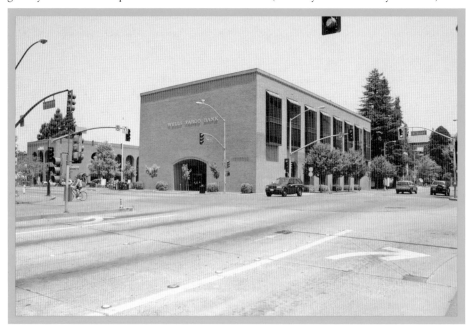

AGENTS OF CHANGE: DEVELOPERS, QUAKES, AND WARS

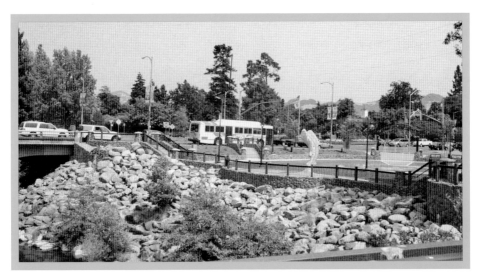

The view below, looking east toward the iron bridge over Santa Rosa Creek, shows Luther Burbank's home in the background. Over the years Santa Rosa Creek became obscured by building and development in the city. In recent years, the City of Santa Rosa has sought to restore the creek as a recognizable feature on the landscape. The contemporary image above shows the results of some of those efforts. The change in community values and aesthetics led to the "rediscovering" of the creek as an important feature of the city. (Courtesy Gaye and John LeBaron collection.)

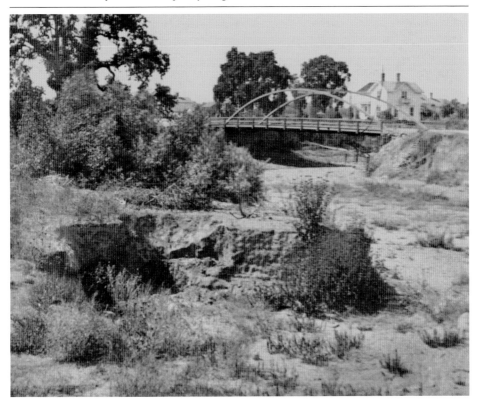

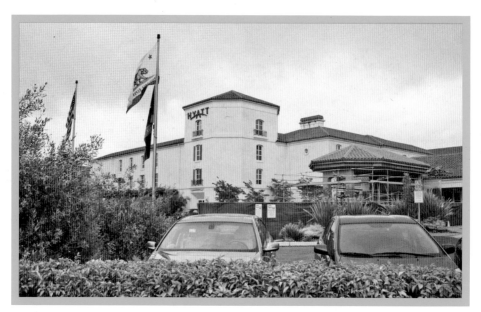

The image below of Grace Brothers Brewery, established in 1897, reflects a time when Santa Rosa and the surrounding agricultural region was a national leader in the production of hops. Changing tastes, a blight of mildew, and new harvesting techniques eroded Sonoma County's hops industry by the 1950s, and places like Grace Brothers faded away. The site along Santa Rosa Creek remained vacant for years after the Grace Brothers buildings were torn down. In 2001, a large hotel and conference center (shown above) was built on the site, reflecting, to some degree, Santa Rosa's shift from farm town to city. (Courtesy Sonoma County Museum.)

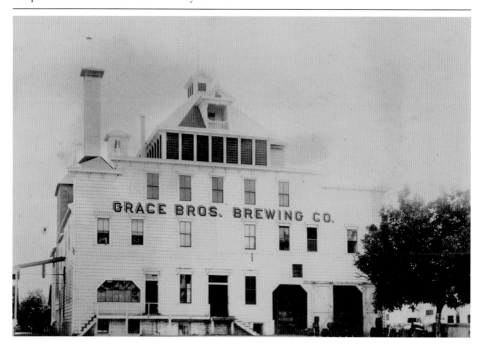

AGENTS OF CHANGE: DEVELOPERS, QUAKES, AND WARS

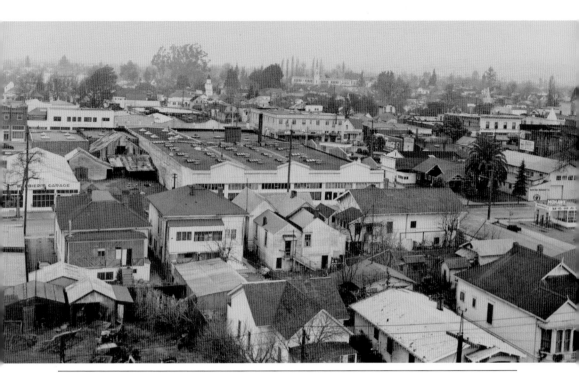

Taken in 1941, the view of Third Street above was captured from Second and Wilson Streets at the Grace Brothers Brewery. The two views show some dramatic changes. The ramshackle housing and the semi-industrial railroad yard–like feel of the 1940s neighborhood has been replaced by the Hyatt Hotel and Conference Center, which is adjacent to the Railroad Square dining, shopping, and tourist area. The limo bus in the parking lot of the Hyatt (below), no doubt preparing to take visitors wine tasting, is a symbol of how drastically the area has changed. (Courtesy Sonoma County Library.)

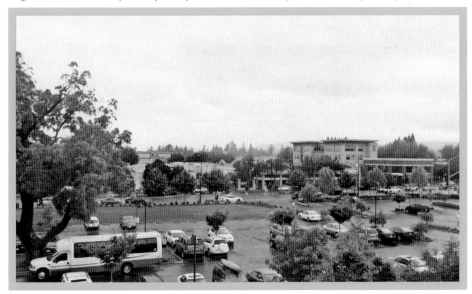

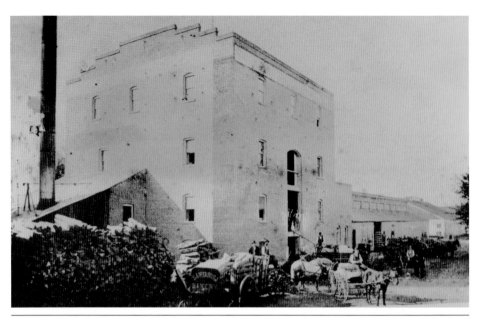

The Santa Rosa Flour Mill, pictured above, was built in 1890 along Wilson Street near Sixth Street. The 1880s and 1890s saw Santa Rosa evolve from a purely small farm town, to a community with large-scale operations such as tanneries, canneries, and mills such as this one. The mill, which sits along the railroad line, was heavily damaged in the 1906 earthquake, but the northern end of the structure was saved. The mill was back in operation by 1908. Recently, the mill building housed the North Bay campus of the New College of California. (Courtesy Sonoma County Museum.)

AGENTS OF CHANGE: DEVELOPERS, QUAKES, AND WARS

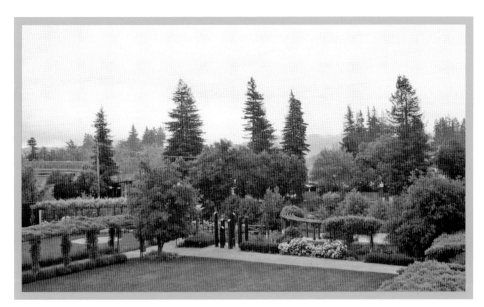

Below, another 1941 image taken from Grace Brothers Brewery looks south onto the western part of Santa Rosa. A large portion of these neighborhoods was inhabited by European immigrants coming in the 1880s and 1890s, including a large number of Italians. Several Italian hotels emerged on the west side, and the work of skilled Italian stonecutters can be seen in the basalt brick buildings in the area in and around Santa Rosa. The contemporary image above shows the manicured grounds of the Hyatt Hotel, with a few older residences barely visible in the background. (Courtesy Sonoma County Library.)

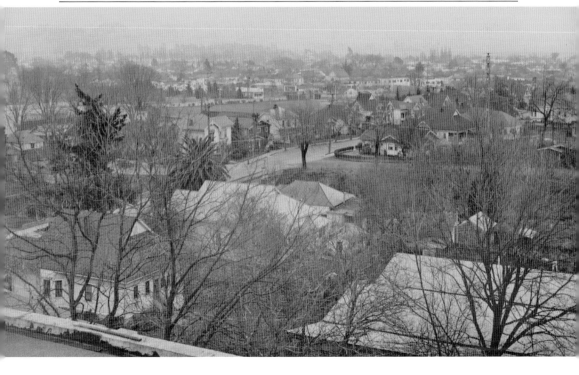

Peeking out over the courthouse area, the elevated view below looks out toward the intersection of Second and D Streets. This part of the town once made up the predominantly Chinese area of Santa Rosa. In its heyday, the Chinese neighborhood had restaurants, stores, and boardinghouses. However, no other segment of the city faced more prolonged and intensive racial animosity than the Chinese. Today much larger buildings, above, hem in Second Street. (Courtesy Gaye and John LeBaron collection.)

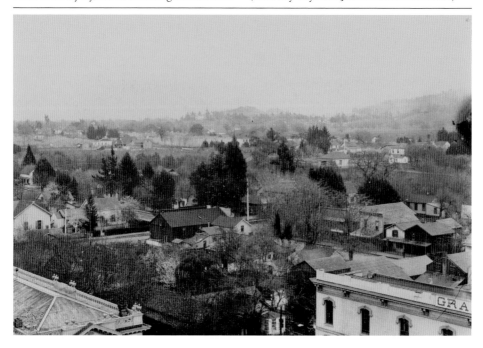

AGENTS OF CHANGE: DEVELOPERS, QUAKES, AND WARS

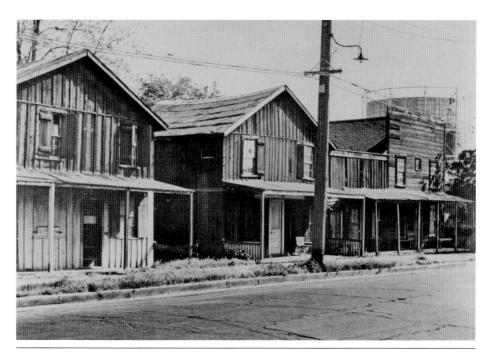

The view of Second Street above, taken in the 1950s, shows the fading remnants of the Chinese section of the city. One of the last residents of the original Chinatown, Song Wong Bourbeau, recorded an oral history with local historian and columnist Gaye LeBaron in 1986. She described, among other things, the role her father played as a labor broker, contracting workers for local ranchers during harvest times. The ranchers would come into the Wong family's store and make arrangements with Song's father to provide a work crew. Today the stretch of Second Street that was the heart of the Chinese neighborhood is a pedestrian thoroughfare linking D Street to Santa Rosa Avenue. (Courtesy Gaye and John LeBaron collection.)

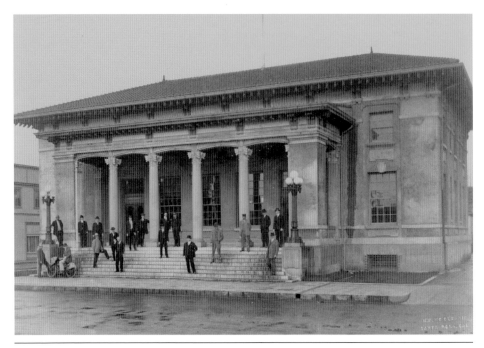

Built between 1908 and 1909, the Santa Rosa Post Office (above) symbolized Santa Rosa's recovery from the devastation of the 1906 earthquake. Situated at the corner of Fifth and A Streets, the building was state of the art at the time of its construction. The building's history is connected to another large quake in 1969 that kicked off a spate of redevelopment in Santa Rosa. The facility, which ceased operation as a post office in 1965, was nearly demolished to make way for a shopping mall when it was saved through the efforts of historic architect Dan Peterson. The building was eventually moved to Seventh Street where it is now the Sonoma County Museum. The original site of the building is now boxed in by the Santa Rosa Plaza Mall and parking structures, pictured below. (Courtesy Sonoma County Museum.)

AGENTS OF CHANGE: DEVELOPERS, QUAKES, AND WARS

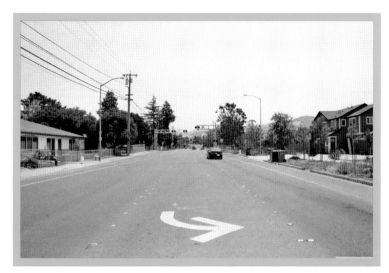

Looking east along Hearn Avenue, west of the railroad tracks, the earlier image below, taken in 1949, shows the road surrounded by orchards and a vista extending a considerable distance to the east. The widened roadway of the contemporary image above leads to a freeway overpass that empties onto to frequently clogged Santa Rosa Avenue. Recent and projected growth has caused concern among city planners over how to deal with traffic congestion, which has left residents of some areas virtually locked in by the freeway and congested overpass. (Courtesy Sonoma County Library.)

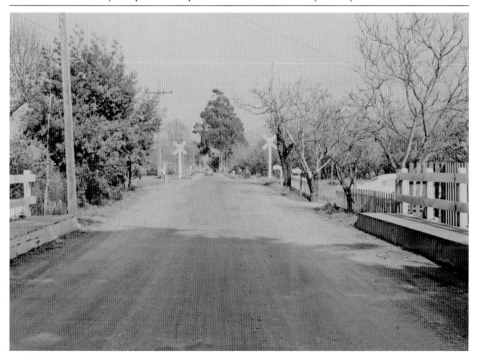

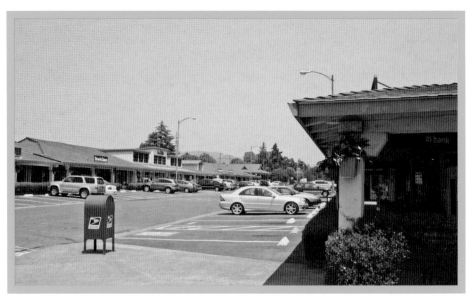

Magowan Avenue was at the heart of Santa Rosa's post–World War II development. The industrial-scale growth that swept over much of the Bay Area did not make it to Santa Rosa, but after the war, several developers seized opportunities for growth and profit. Among them was Hugh Codding, who built a small shopping center in Santa Rosa and then moved on to Montgomery Village. The shopping area shown in these images served the hundreds of homes that Codding built nearby. The eventual annexation of Montgomery Village in 1951 nearly doubled the population of Santa Rosa, bringing it to 31,000 individuals. (Courtesy Sonoma County Library.)

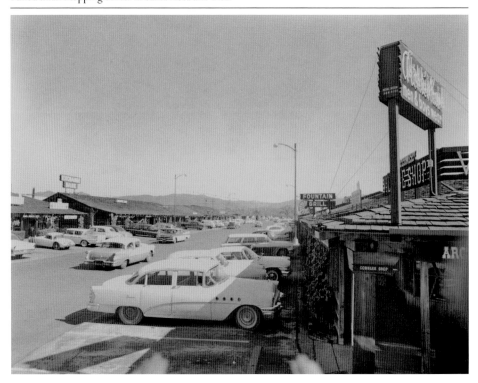

The 1965 image above, looking north along Farmer's Lane, shows an area of Santa Rosa that developed in the wake of World War II. In the foreground is a ranch along Bennett Valley Road that looks relatively untouched by postwar changes. Beyond it can be seen Hugh Codding's Montgomery Village development, with homes nestled in among the trees both to the east and west of the shopping area. New apartment complexes and other buildings are visible in the contemporary image below. (Courtesy Sonoma County Library.)

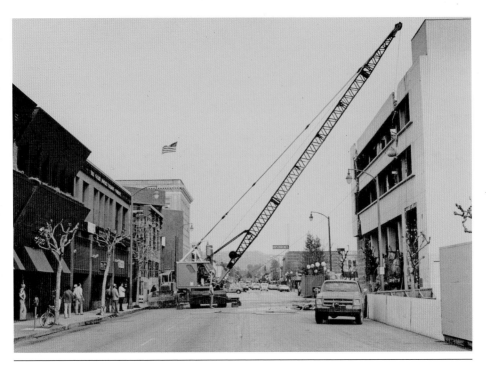

A not-so-subtle harbinger of change, a wrecking ball is shown above on Fourth Street near B Street engaged in demolition in 1970. The 1969 earthquake, actually a pair of quakes, measured 5.6 and 5.7 on the Richter scale. While it did not send buildings to the ground like the 1906 quake, many structures were damaged, and a serious round of redevelopment occurred in Santa Rosa, transforming the city. (Courtesy Sonoma County Museum.)

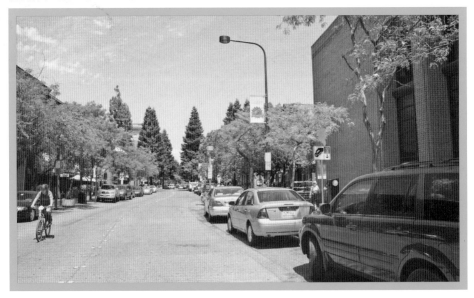

CHAPTER 7

NEW LIMITS
GROWING AT THE EDGES

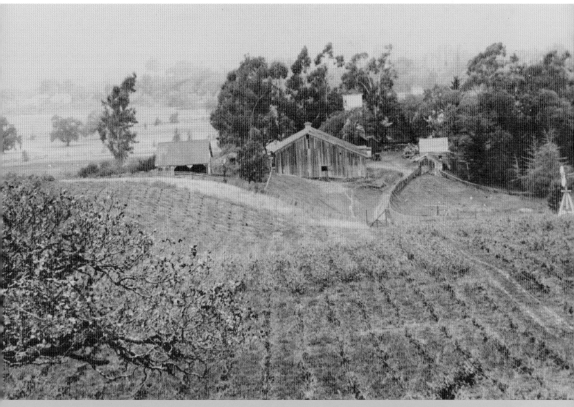

Brook Hill was one of many farms that skirted the boundaries of Santa Rosa in the 19th and early 20th centuries. Brook Hill, which sat at the southern edge of Santa Rosa, was owned by the Dixon family at the end of the 19th century. Many family farms, including Brook Hill, were swallowed up as Santa Rosa expanded. (Courtesy Gaye and John LeBaron collection.)

The structure pictured below in 1934 is the Carrillo Adobe, the first non-Native American building of any permanence in the Santa Rosa Valley, built in 1837. Originally the heart of a Mexican rancho and later part of the short-lived town of Franklin, the adobe sat in the Hahman family orchards on the eastern periphery of Santa Rosa for many years. Only in the mid-20th century did the town expand far enough to encompass the building known as "The Place Where Santa Rosa Began." Today what remains of the adobe is preserved under a protective structure, shown above. (Courtesy Sonoma County Museum.)

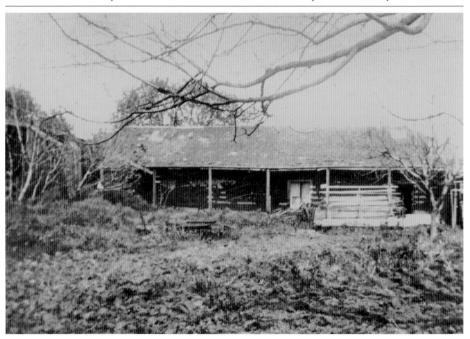

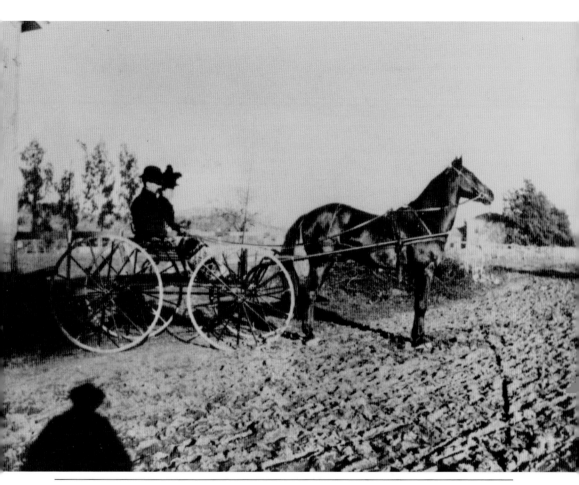

William and June Healy are shown in their buggy at McDonald Avenue and Thirteenth Street. This vintage shot, taken in 1898, provides a look at the area where town became country. Today the open space beyond the Healy house is a quiet residential neighborhood. (Courtesy Sonoma County Museum.)

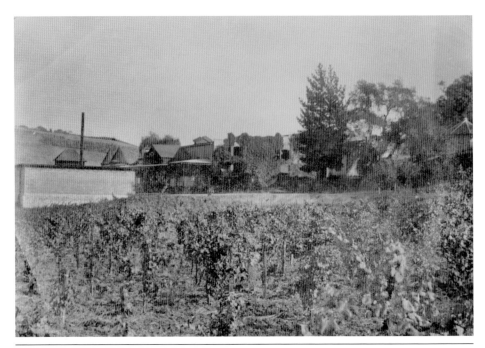

A mere crumbling ruin of Fountaingrove Winery remains today, adjacent to the parking lot of a large medical device company shown below. The former vineyards of Fountaingrove, once north of Santa Rosa's city limits, are clogged with housing developments, hotels, and businesses. The winery, shown above, was one of the first in California with significant international interests. By 1878, there were over 350 acres of vineyard on the property, and the winery was producing over 200,000 gallons of wine a year by the end of the 19th century. (Courtesy Sonoma County Museum.)

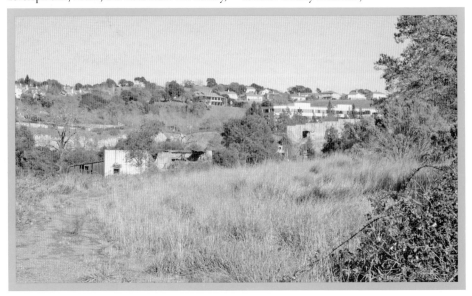

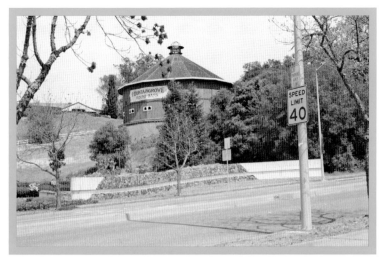

The Fountaingrove Round Barn, shown in this image below from about 1910, has survived to become one of Santa Rosa's iconic structures. There are 11 historic round barns in the state of California, two of them in Santa Rosa and one more in nearby Windsor. The round barn was built in 1899 by Kanaye Nagasawa, the Japanese proprietor of Fountaingrove Winery. The Fountaingrove area of Santa Rosa was established as a religious community in 1875 by leader Thomas Lake Harris. Nagasawa arrived in Santa Rosa as one of Harris's most trusted followers. While the round barn (above) has remained, it is now surrounded by modern development and has itself been the subject of several aborted plans to convert it to a publicly accessible business. (Courtesy Sonoma County Museum.)

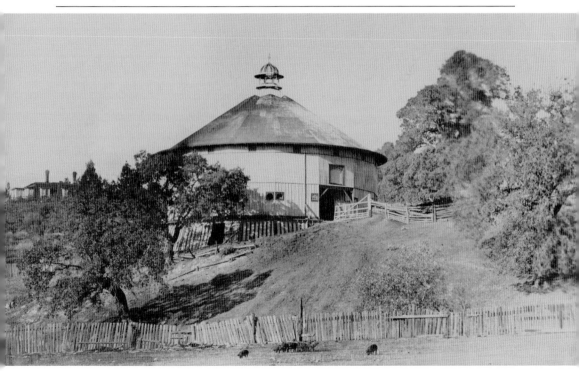

The image below was taken from the Presbyterian church built by Hugh Codding, one of Santa Rosa's most noteworthy postwar developers. Codding gained widespread attention for his publicity stunts, including the construction of the original church in about five hours. The surrounding area is Codding's Montgomery Village, which replaced many of the prune and walnut orchards in the eastern part of Santa Rosa with homes, shopping centers, and other structures in the 1940s and 1950s. The Presbyterian church still occupies the same location, although in a building of more recent—and lengthy—construction. The view above is taken from the church's front lawn. (Sonoma County Museum.)

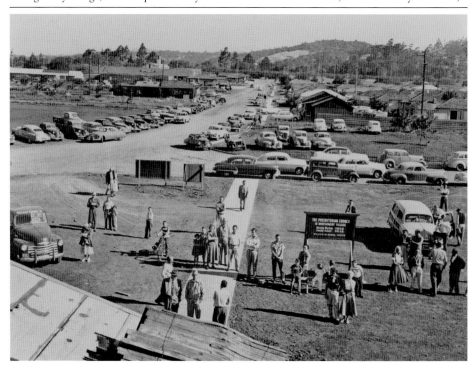

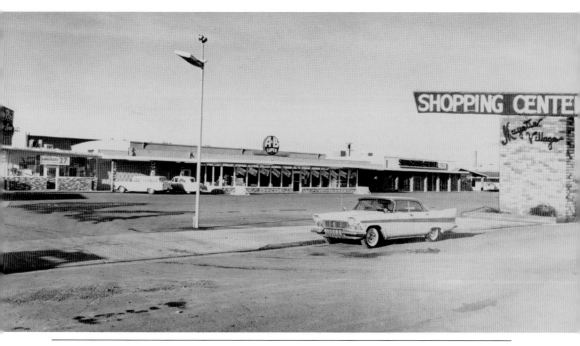

The Mayette Village Shopping Center was built at Yulupa and Mayette Avenues in the Bennett Valley region of Santa Rosa in the 1950s. Bennett Valley, the site of several large, early Santa Rosa area ranches, saw an increase in development in the 1950s like other peripheral areas of the city. The shopping center shown below is now anchored by Whole Foods, but half a century ago it was A and B Super and Po-Po's De Luxe Hamburgers, shown above. It is not clear whether the brick sign for Mayette Village was ever built, since it is clearly cut and pasted into the image here. (Sonoma County Library.)

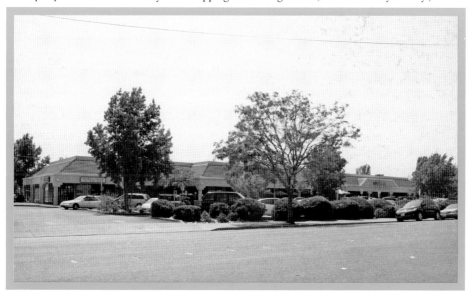

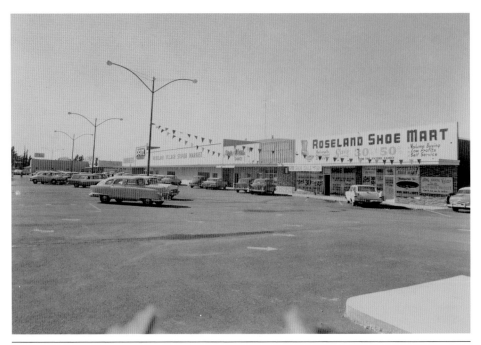

Built in the 1950s by developers Hugh Codding and John Paulsen, Roseland Shopping Center in western Santa Rosa was anchored for many years by the large grocery stores pictured above. With the departure of Albertsons in 2003, the retail center in the heart of Santa Rosa's growing Latino community has struggled economically, below.

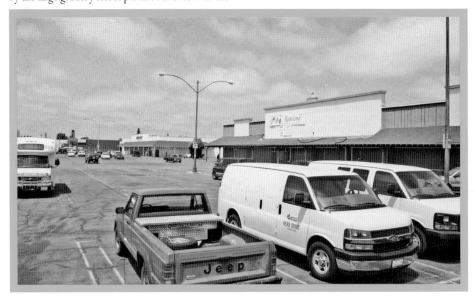

Coffey Lane near Steele Lane in the 1950s was bare land and orchards, as seen in the image below taken late in the decade. The area in the northwest of Santa Rosa was transformed in the early 1960s through the efforts of Santa Rosa Enterprises, a development firm headed by Hugh Codding and H. C. Hilliard.

With the construction of Coddingtown Shopping Center, Santa Rosa took a significant step toward spreading beyond the downtown area. The orchards of past years have been replaced by businesses such as the self-storage facility pictured above.

DISCOVER THOUSANDS OF LOCAL HISTORY BOOKS
FEATURING MILLIONS OF VINTAGE IMAGES

Arcadia Publishing, the leading local history publisher in the United States, is committed to making history accessible and meaningful through publishing books that celebrate and preserve the heritage of America's people and places.

Find more books like this at
www.arcadiapublishing.com

Search for your hometown history, your old stomping grounds, and even your favorite sports team.